Indian Lake

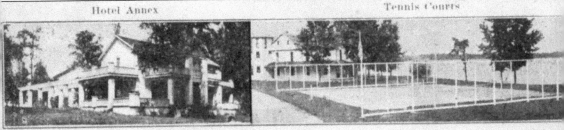

Hotel Annex Tennis Courts

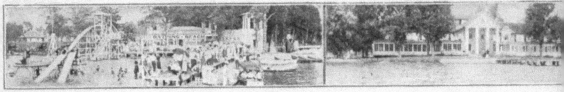

Bathing Beach Orchard Island Hotel

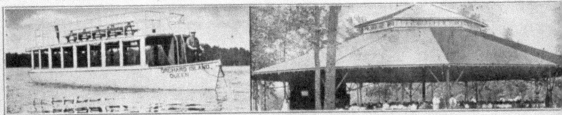

Orchard Island "Queen" Colosseum.

VIEWS OF ORCHARD ISLAND, OHIO SUMMER RESORT,
Hotels, Cottages, Dancing Hall, Bathing Beach, Tennis, Boating, Etc., Etc.

This postcard, mailed in 1922, advertises some of the attractions on Orchard Island, including the Orchard Island Hotel, built in 1901 by Frank "Shad" Reed, and the Hotel Annex, built a decade later by Rev. Alexander Tarr. (Author's collection.)

ON THE FRONT COVER: This view of Russells Point Harbor in the mid-1920s looks northward toward Indian Lake. Sandy Beach Amusement Park, located on the east shore, opened in 1924. The *Evelyn* was a sightseeing boat that ferried passengers around the lake. While the amusement park has been gone for almost as many years as it was in operation, the steel bridge connecting both sides of the harbor has been restored in recent years and continues to be a landmark in the landscape of Indian Lake. (Author's collection.)

ON THE BACK COVER: The State Bathing Beach on Orchard Island was the oldest swimming beach on Indian Lake. Each beach featured elaborate water slides and other equipment to keep patrons entertained. Some of the beaches were on islands only accessible by boat, including Sandy Gables (a few hundred feet west of Wolf Island) and Crystal Beach (near Artist Isle). On the north side of the lake, the Avondale Bathing Pool offered relief in times of hot weather. (Author's collection.)

POSTCARD HISTORY SERIES

Indian Lake

Cornelis van der Veen

ARCADIA
PUBLISHING

Published by Arcadia Publishing
Charleston, South Carolina

Library of Congress Control Number: 2018942544

For all general information contact Arcadia Publishing at:
Telephone 843-853-2070
Fax 843-853-0044
E-mail sales@arcadiapublishing.com
For customer service and orders:
Toll-Free 1-888-313-2665

Visit us on the Internet at www.arcadiapublishing.com

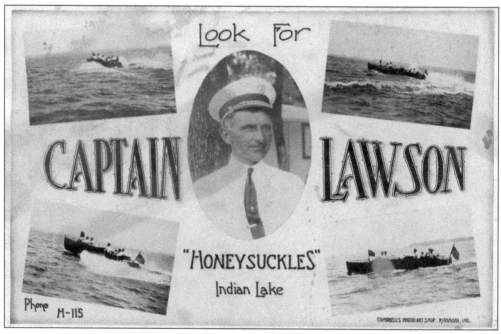

Captain Lawson was among the first to use motorized boats to ferry people around the lake. (Author's collection.)

CONTENTS

ACKNOWLEDGMENTS

The order of images presented in this book benefitted greatly from the comments of Bryan Pahl. The text improved much thanks to the editorial skills of Sue Pitts, who carefully read through an earlier draft of this book. The series of three *Old Time Photo Album of Indian Lake* books published by Bud Grandi over a 30-year period provided many details about photographs and postcards. Also indispensable during my research and writing were *Indian Lake: A Snapshot in Time*, by Jeff Weidner and Joe Meier, and *A Short History of the Area*, published by the Indian Lake Area Historical Society. The early photographers, especially Harry Mansfield and John Brentlinger, are to be commended for documenting scenes around the lake during the first two decades of the 20th century. Many people contributed directly and indirectly by sharing their stories and memories, including Karen, Linda and Richard, Mary and Tom, Kathy, and Katie. Finally, thanks are owed to Caitrin Cunningham at Arcadia Publishing for checking text and image quality.

Publication of this book would not have been possible without the many online vendors who offered postcards and photographs for sale. All images contained in this book are taken from my personal collection of more than 800 postcards and old photographs. When I started this project, I had no idea that our humble lake would yield such a treasure trove of historical postcards.

INTRODUCTION

The story of Indian Lake begins with an ice sheet covering much of the North American continent and extending as far south as northwestern Ohio. After the ice sheet started retreating northward some 12,000 years ago, it left behind the Great Black Swamp, a muddy mix of sediments and ample meltwater. The main swamp extended from the area around Fort Wayne, Indiana, to the southern tip of Lake Erie, but pockets could also be found farther south. And where isolated half-buried blocks of ice were left behind as the glacier receded, kettle lakes were formed as these buried ice blocks slowly melted. One such lake was Indian Lake, with an approximate area of 640 acres and located in northern Logan County; two nearby smaller lakes were Bear Lake and Otter Lake. Although the exact location is now hard to determine, the original lake was located in the southeastern part of the present lake, roughly bounded by present-day Lake Ridge Island, Seminole Island, and Artist Isle.

Little is known about the origins of the earliest inhabitants of the region or where they disappeared to. The only artifact these peoples left behind was a circular mound about 12 feet in diameter, similar to other Indian mounds found in Ohio. This mound, near Dunn's Pond on Lake Ridge Island, has been carefully preserved, although no exploration of its contents has been permitted. Later, the Miami Indians used the region for hunting, fishing, and foraging, traveling mostly along elevated ridges to avoid the low-lying swampy areas. For many years, the Miami Indians were one of the most powerful and numerous of the Northwest Indian tribes. But by the middle of the 18th century, the numbers and strength of the Miami tribe were declining, and other Indian tribes became more prominent. When white settlers arrived, Indian Lake was in Shawnee territory, and there were numerous other tribes around the area.

Closest to Indian Lake was the Wyandotte town of Solomontown, located about midway between present-day Belle Center and Huntsville. The other Indian settlement close to the lake was the Shawnee village of Lewistown, named after its chief, John Lewis, an Indian who had adopted his name from the white man. The Shawnees had villages at Wapatomica and Macachac and along the Mad River. The Wyandotte Indians had a village at Zanestown (now Zanesfield), and the Mingo chief Logan had a village along the Scioto River, just east of present-day Kenton. The Shawnee chief Blue Jacket had a town located on the site of present-day Bellefontaine.

Probably the first time the area was visited by settlers of European descent was during the expedition led by Gen. George Rogers Clark, who is believed to have passed by Indian Lake in 1786. Soon thereafter, the Battle of Fallen Timbers occurred on August 20, 1794. This battle—fought near present-day Maumee and the final battle between the young republic and a coalition of Native American tribes supported by the British army—decided who would control the Northwest Territory (an area north of the Ohio River, east of the Mississippi River, and southwest of the Great Lakes). According to the 1783 Treaty of Paris, the land had been ceded to the United States, but the Native Americans living on these lands refused to comply with the treaty, primarily because they had been excluded from the Paris negotiations. Following the Treaty of Greenville on August 3, 1795, most of Ohio was secured for settlement, and the federal government of the United States gained access to the western Great Lakes and

the western Ohio River valley. Native Americans were delegated to Indian reservations, such as the one around Lewistown in Washington Township.

Gradually, the Native Americans returned to their old lands, and around the start of the 19th century, many of the Indian villages that had been abandoned a few decades earlier were rebuilt. By the time Ohio became a state in 1803, much of the Indian Lake area was still occupied by Native Americans. The Lewistown Reservation hindered settlement in the northwestern part of Logan County for several years, which accounts for the late settlement of the three townships bordering Indian Lake: Stokes on the west side, Washington on the south side, and Richland on the east side. By 1840, out of a population of around 145,000 in the entire county, only 517 were living in Washington Township, 299 in Stokes Township, and only a handful in Richland Township.

Over the next three decades, many treaties were signed only to be broken by the white settlers as they continued expansion into Ohio and Indiana. A final treaty in August 1831 was negotiated with the tribes at Lewistown and Wapakoneta. As a result of this treaty, several hundred remaining Native Americans were forcibly removed from Ohio and moved to the Indian Territory near present-day Kansas.

The first white settlers encountered a heavily timbered country that was wet and swampy. Building a home and harvesting enough from the land to sustain a family proved challenging, and typically three to five years passed before a frontier farm could be relied upon to provide support. Game of all kinds, but especially deer and wild turkey, was abundant in the early days of settlement. Wolves were numerous and so destructive to sheep that strong pens had to be constructed to confine the sheep at night. Occasionally, a bear would pay a visit to the settlement; however, this was by no means frequent, and usually a hunt ensued in which the bruin lost his life.

During the summer of 1810, James Hill and his wife and their six children, together with Samuel Tidd, his brother-in-law, and his wife, settled in Zanesfield, where they remained for seven years. Early in the summer of 1817, Hill erected a cabin in the southwest portion of what is now Richland Township. Soon after, Thomas Rutledge and Thomas Burton, each of whom had a large family, settled in the immediate vicinity of Hill's cabin. These three families are considered the pioneer settlers of Richland Township.

In 1825, construction began on the 301-mile-long Miami and Erie Canal. The canal created a water route from Cincinnati (on the Ohio River) to Toledo and Lake Erie. In 1850, the state legislature passed an act to utilize Indian Lake as one of three feeder reservoirs for the canal, with the others being Grand Lake St. Marys and Lake Loramie. These reservoirs were needed because natural springs provided insufficient water supply to operate the 100 or so canal locks. There was plenty of water available in the winter and early spring, but the canal season ran from early April to late November, and it was during the greater part of this season that the streams were lowest and often entirely dry. In 1850, the Board of Canal Commissioners passed a resolution to utilize Indian Lake as a water reservoir.

In order to increase the size of the lake, the surrounding land was condemned and its owners given money to relocate elsewhere. A bulkhead and waste weir were built in Washington Township where the Great Miami River flowed out, creating a 1,000-acre lake that was named the Lewistown Reservoir. A few years later, work was started to expand the lake, and by 1860, one year before the start of the Civil War, the lake covered 6,334 acres. Irish immigrants were brought in to do most of the backbreaking work using hand shovels, picks, and carts. A floodgate was constructed at the west end of the weir to supply water to the Great Miami River.

In 1877, Senator Beatty introduced a bill to abandon the Lewistown Reservoir, which, according to him, "creates sickness in the county and is a nuisance generally." At an average price of $30 per acre, the total proceeds of the sale of the surrounding lands would be around $200,000; the annual interest on this amount would be half of the annual income from state-issued leases. As reported by the *Sandusky Daily Register* on March 9, 1877, "the bill has passed the Senate and soon will be acted on in the House. If it becomes a law, it will foreshadow the

abandonment of the canals in the state. I doubt the propriety of this move. We are not yet ready for it. The usefulness of the canals is by no means at an end, and I think the bill will be defeated in the House." And so it went.

By the early 1890s, boat travel on the Miami and Erie Canal had dwindled, and the Lewistown Reservoir was no longer needed as a feeder lake. Some farmers in the region opinioned that the lake should again be drained. The *Lima Times Democrat* of May 19, 1893, reported on the "determined stand taken by Hardin County farmers for the abandonment of the Lewistown Reservoir."

Five years later, however, on January 11, 1898, the *Lima Times Democrat* reported that

> a movement that will be hailed with delight and advocated by every sportsman in the state was inaugurated in this city last night. Representatives of the local outing clubs met at the City Book Store and organized by electing T.A. Robinson president and Wilbur Fisk secretary. The objective of the movement is to have the Lewistown Reservoir, 25 miles southeast of this city, set aside as a permanent public lake as was done with the Licking Reservoir. The proposition to drain and abandon all state canals, it is feared, might result in the abandonment of the Lewistown Reservoir or the sale of the lake to capitalists. Circular letters and petitions will be sent to every county in the state and the petition will be so strongly endorsed and the movement so vigorously advocated that the desired end will doubtless be attained.

A little more than two months later, on March 28, 1898, the newspaper reported that "the bill to convert the Lewistown Reservoir into a public park has passed the state senate." The newly named Indian Lake was dredged and increased in size. At present, the lake covers 5,800 acres, with a shore line of 29.2 miles. It is the second-largest inland lake in Ohio (after Grand Lake St. Marys).

The first community to spring up along the banks of Indian Lake was Lakeview, incorporated in 1895. Its first settler was George Hover, who planted two pine trees on Main Street and built a cabin shaded by these trees. A map of Stokes Township published in 1875 shows some neighboring cabins on land also owned by the Hover family but no signs of a town or settlement. In 1881, the town was platted and steadily grew over the following years. In 1895, two hundred people aged 18 years or older signed the document to incorporate the village of Lakeview. After the Toledo & Ohio Central Railroad arrived in 1897, followed by the interurban Ohio Electric Railway in 1908, growth of the village and of its vacation resorts rapidly increased. Phone service reached Lakeview in 1899; electricity was established in 1912.

John Russell, after whom the town of Russells Point is named, was born in 1847 near the eastern shores of the original Indian Lake on what is now known as Lake Ridge Island. Most of his early life was spent on his parents' farm just south of what became later O'Connor's Landing. As Russell traveled around the now enlarged Lewistown Reservoir, he noticed a tract of government-owned land jutting out into the reservoir on the southern shore. After his marriage, he decided to lease this marshy, forested land worth $800 and located near excellent fishing grounds. The Piqua office of the Bureau of Public Works, which administered the reservoir and surrounding areas, drew up a lease contract for 15 years on October 1891; the lease provided Russell with seven acres of land at a rent of $48 per year. It was here that Russell built a farmhouse and centered his farming and fishing operations.

Soon, an increasing number of fishermen traveled by horse over muddy roads and through near-impossible conditions for a fishing vacation at the lake. Often, these travelers needed help or food after they arrived. At first, the Russell family was only too glad to help these weary travelers, but as the first season ended and the second and third years of increasing numbers of fishermen came and went, the added burden on the family began to be too much for a man trying to raise a growing family and with heavy chores of his own. Doubts about troublemakers who often accompanied the fishing parties and parties carried on by vacationers, as well as

the ever-increasing number of sportsmen entering the area each year, led Russell to long for the plain and peaceful farm life he had known as a child. And so, only three years after he signed the lease with the government, Russell sold the lease in 1894 to James Marshall and Elmer McLaughlin. The new location for the Russell farm was a full day's drive north of the Point, near the town of Ada. On this farm, Russell raised his family and lived out the rest of his life. He died in 1925 at age 78. Even though he was one of the first to have realized the growth potential of the area, his way of life and outlook on raising a family led him to leave it.

Other entrepreneurs were quick to jump at the opportunities Indian Lake offered, and for much of the 20th century, Russells Point was known as "Ohio's Million Dollar Playground." Sandy Beach Amusement Park opened on the east side of the harbor with much fanfare on May 30, 1924. The park was the brainchild of Samuel "Pappy" Wilgus and his son, French Wilgus, who had developed Sandy Beach Island into a popular bathing beach that opened on May 30, 1912. In addition to rides and the usual attractions, the amusement park also hosted big band concerts in the Minnewawa Dance Pavilion. Over the years, the park had several owners until it finally closed in the mid-1970s. With the demise of the amusement park, the many hotels around the lake also gradually disappeared.

No single factor was responsible for the gradual decline and ultimate closing of Sandy Beach Amusement Park. But the annual riots during the 1960s certainly played a crucial role. On July 5, 1961, the *Lima News* reported on the first riots at Indian Lake:

> The unexpected explosions began shortly after midnight Tuesday when a group of young people began fighting and throwing tables around in a beer garden. The crowd, which was estimated at between 400 and 1,000, blocked off Ohio 366, the main street in Russells Point. The demonstrations finally ended, at least for the time being, around 2:30 a.m. with the arrival of 20 Ohio patrolmen and auxiliaries and a wetting down by local fire department hoses.

According to Gene Gooding, the mayor of Russells Point, there did not seem to be any particular ringleaders, and this seemed "just a case of a lot of young fellows with nothing better to do."

After 1961, the riots became an annual event for vacationing teenagers on the Fourth of July weekend. In 1965, the riots were so bad that the Ohio National Guard was called to the lake. It was not until 1972 that Russells Point had another peaceful Fourth of July weekend. Over the decade of rioting, more than 900 people were arrested, but that was of little comfort to injured bystanders or to businesses that suffered damages.

Since the amusement park closed, Indian Lake has transitioned. In the late 1980s, the area on the lakeside of the old Dike Road between Russells Point and Old Field Beach was filled in, and a bike path and picnic area were established. The state park campground on the north side of the lake was built in the 1960s and brought new visitors to the lake region. Large manufacturing companies came to the area starting in the 1990s, including Honda Transmissions and World Class Plastics. And thanks to the Indian Lake Watershed Project, Indian Lake has some of the cleanest water in the state of Ohio.

One

EARLY YEARS

When the Lewistown Reservoir was created to supply water to the Miami and Erie Canal, there were no towns or villages on the shores of the lake. The village of Richland was platted in 1832 and flourished for several years until the railroad bypassed Richland in favor of Belle Center in 1846. Belle Center grew to be a prosperous community that was incorporated in 1867. Another town that prospered after the arrival of the railroad in 1847 was Huntsville, platted in 1846 by Alexander Harbison, a county surveyor. South of Indian Lake, Lewistown became the largest settlement after the last of the Native Americans were forcibly removed from their reservation and relocated to Kansas in 1832.

Lewistown was platted in 1835 by Maj. Henry Hanford, who purchased a 25-acre tract as soon as it was offered for sale by the government. The Lewistown Reservoir was created in 1850 by building a bulkhead and waste weir where the Great Miami River flowed out of the much smaller existing Miami or Indian Lake. A floodgate was constructed to supply water to the Great Miami River. By 1858, after expansion of the lake, the Lewistown Reservoir covered 6,334 acres. The residents in villages around the lake were familiar with the Lewistown Reservoir as an excellent place for hunting and fishing, and word soon spread around the region; people from farther away started to travel to these towns by train, and then by horse and buggy to the lake itself.

This led to entrepreneurial men like William Clarke and Frank "Shad" Reed building hotels on the lake to accommodate the growing numbers of upper-class visitors and vacationers. Clarke created the Lake Ridge Resort in 1890 by connecting what was a peninsula to the mainland and building a spacious summer hotel on the shores of Indian Lake. Reed built a first-class hotel on Orchard Island and also connected the island with the mainland by means of a bridge.

These early lodgings were mostly geared toward more affluent travelers—those people and families who could actually afford to travel. From these humble beginnings, a hospitality industry emerged that continues thriving to this day.

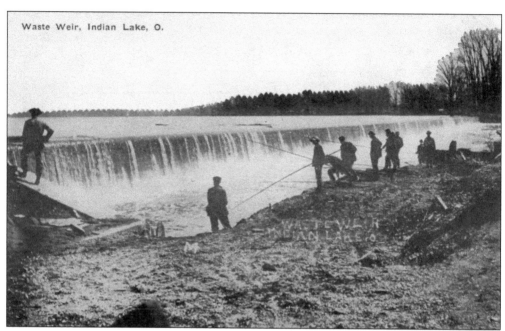

The original weir measured 600 feet wide and consisted of timber cribs filled and backed with gravel. About 25,000 cubic feet of framed timber and ties, plus 28,000 board feet of planks, were used for the construction. On June 24, 1907, the waste weir gave way, and the water poured out of a breach 30 feet wide, causing the Miami River to overflow its banks, devastating farms for miles downstream from the lake.

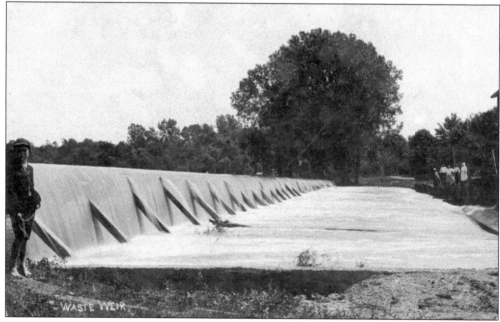

The barefoot boy on the left side of this black-and-white postcard was carefully removed when the card was reprinted as a hand-colored postcard. The group of people to the right was allowed to remain on later versions, although their clothing remained black-and-white.

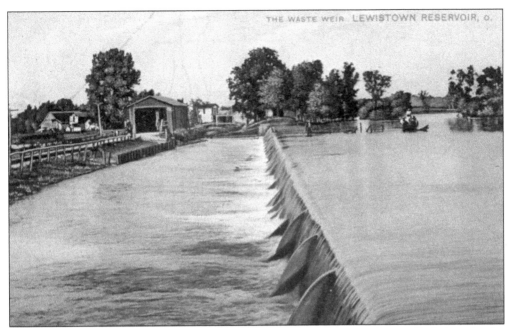

This postcard offers a view looking west across the waste weir toward Russells Point. On the left is the covered bridge on what later became US 33 and is now State Highway 366. The building to the right of the road is the National Hotel, later called the Hotel Bulkhead. The covered bridge was washed away during one of the flood events in the early 20th century and replaced with a cement bridge.

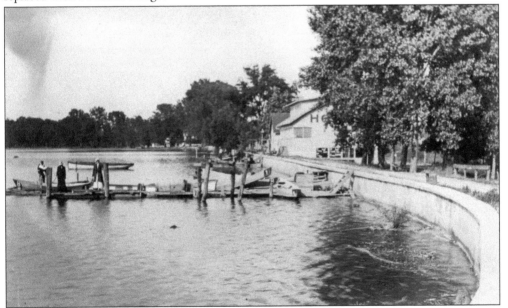

This real-photo postcard shows the Hotel Bulkhead and adjacent boat dock immediately west of the waste weir. This postcard was postmarked August 21, 1916, and was one of several individualized cards made for Frank Thomas and his family in Belle Center. In the early days, well-to-do people could hire a professional photographer who took pictures and printed them on postcards to be sent to family and friends.

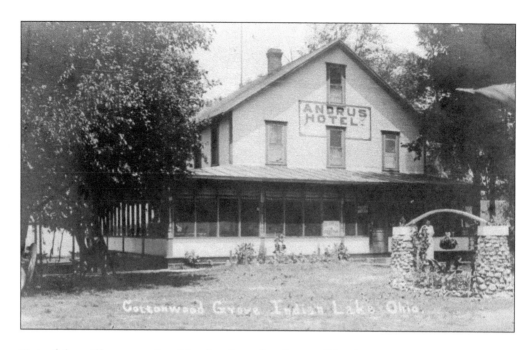

Cottonwood Grove Indian Lake Ohio.

East of the spillway was the oldest hotel on the shores of Lewistown Reservoir, the Andrus Hotel, built in 1871. This area was known as "Cottonwood" after the large cottonwood trees that lined the lake shore. In addition to running the hotel and cottages, in the early days Mr. Andrus also worked the gates at the waste weir. The landing offered boat rentals and sites for camping for those who preferred not to stay in the hotel. Over time, the resort grew to include a lunch and dining room at the hotel, as indicated by the sign in the postcard below. Note how both men and women are dressed in more formal clothing, which must have been rather warm during the summer months.

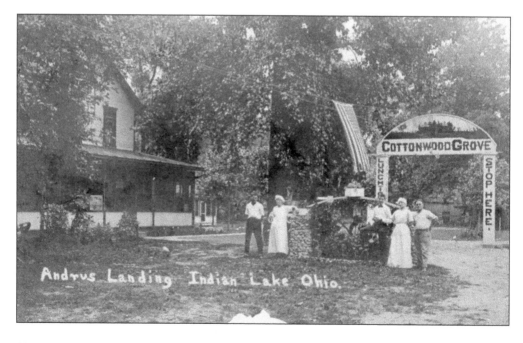

Andrus Landing Indian Lake Ohio.

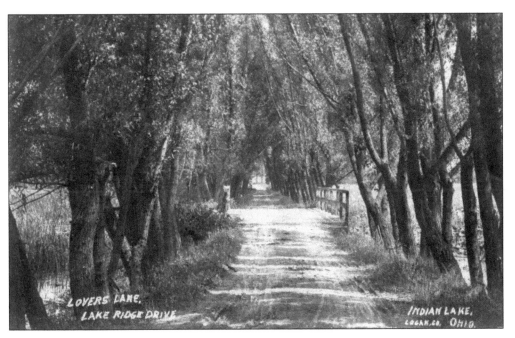

By the end of the 1880s, Harrison Spencer and his brother Washington, who were both farmers from New Richland, had purchased Ridge Island on the east side of Indian Lake as well as 200 acres located south and east of the island. Harrison built a road from the state road to his home along the South Fork of the Miami River. A bridge across the river and a toll road provided access to Lake Ridge Island, which was turned into a fishing and hunting camp. Harrison planted willows along the toll road, and it became known as Willow's Lane or Lover's Lane. The first hotel on Lake Ridge Island was built by John Palmer in the early 1880s. In 1891, William Clarke built a new hotel known as The Inn.

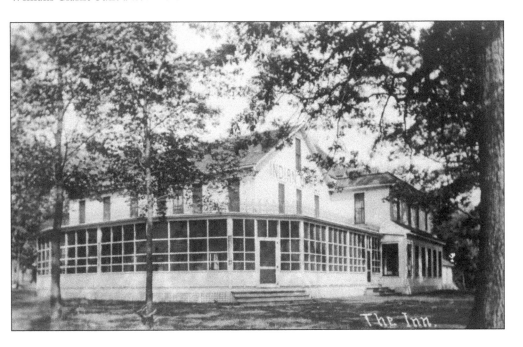

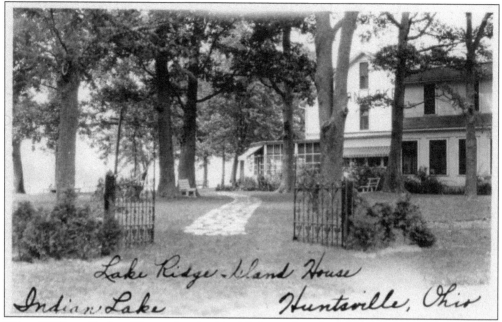

When William Clarke of Pennsylvania visited Lake Ridge Island, he fell in love with Harrison Spencer's daughter, Bertie, and they were married soon thereafter. William and Bertie took over the management of the island. In 1891, William built a hotel with 40 guest rooms, a dining room, parlor, and lobby—"a nice place for nice people." On the hotel grounds, he built a park that included a small zoo that housed wild animals. The hotel burned down in 1937 and was not rebuilt. In later years, the Lake Ridge Resort included modern waterfront cottages, lakefront trailer terraces, a bathing beach, tennis courts, a playground, and docks. The gazebo in the postcard shown below was on the grounds of the hotel. Echo Point offered a tranquil place for fishing and boating.

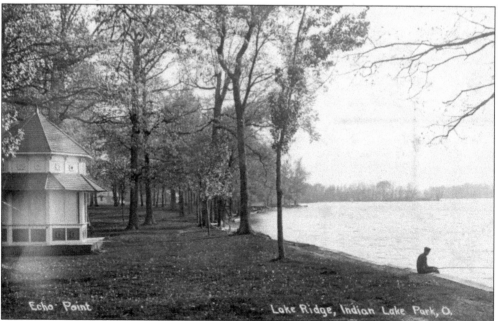

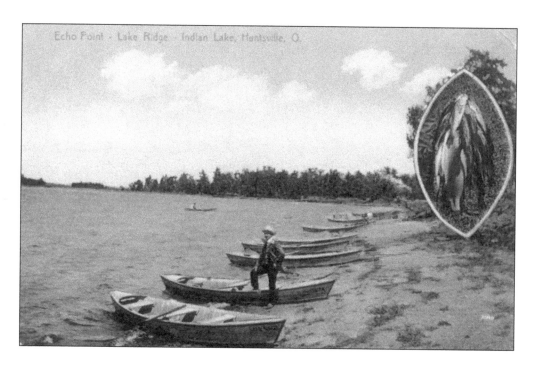

A historian wrote in 1919 that "there is no sound save from those of nature—the splash of water under the oars, the call of the wild birds and the wind in the trees. There is no clock in the hotel. 'Time,' says Mr. [William] Clarke, 'is made for slaves.' There is no electricity in the resort to preserve an atmosphere of rest. Bass fishing is lure enough to anglers 'without the glare of electricity to prolong the day to weariness.'"

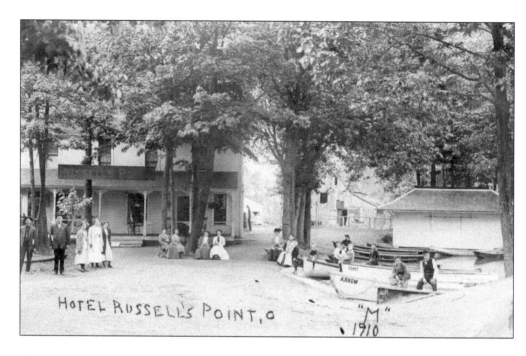

The Hotel Russells Point, previously known as the Sportsmen's Rest, was on the west side of the harbor at the site of John Russell's home. In October 1891, Russell signed a 15-year lease with the State of Ohio, but after only three years he sold the lease and moved his family to lead a more quiet life on a farm near the town of Ada. By then, there were a dozen families living in the community that was named Russells Point in honor of its first resident.

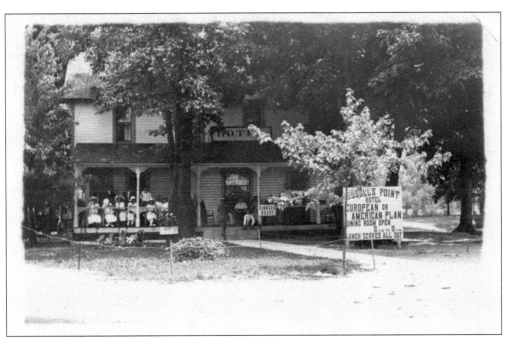

In the spring of 1898, the state senate passed a bill to convert the Lewistown Reservoir into a public park, and Indian Lake State Park was established. This boosted the number of visitors to the lake, and by the beginning of the 20th century, the harbor of Russells Point had become a focal point of leisure activity. On the west side of the harbor, the grounds of the existing hotel were expanded to include a boat landing and boat rental owned by Lafe McElroy. Morris Bundy bought the McElroy property in the early years of the 20th century and built a few more cottages on what is now Wilgus Drive.

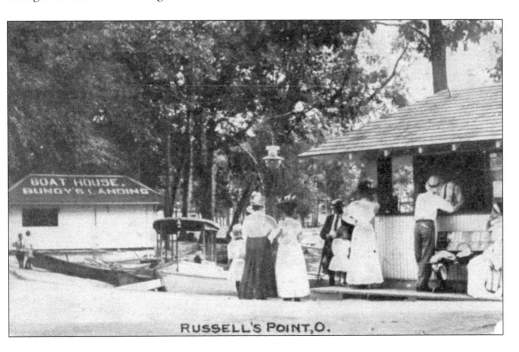

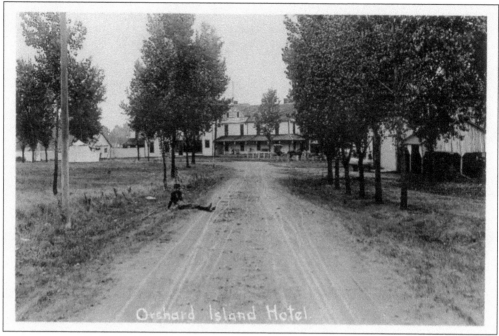

In 1900, Frank "Shad" Reed started construction of a "club house" on what was then still known as McClure's Island. After purchasing most of the island the following year, he replaced the clubhouse with Reed's Cottage, a two-and-a-half-story, first-class hotel. Four thousand North Carolina poplar trees were planted, and a road was built to connect Orchard Island with the mainland. The hotel grounds included stables for horses and a boat landing with four expert guides who were in constant attendance to assist the hotel guests. Reed did not get to enjoy his hotel for very long. By 1904, he had fallen on hard financial times, and Harry Oldham was appointed assignee and took possession of the hotel and its grounds. The probate court decided to keep the hotel, then valued at $37,000, open as a resort because of the good patronage.

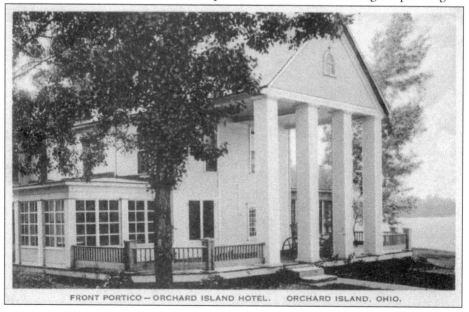

FRONT PORTICO — ORCHARD ISLAND HOTEL. ORCHARD ISLAND, OHIO.

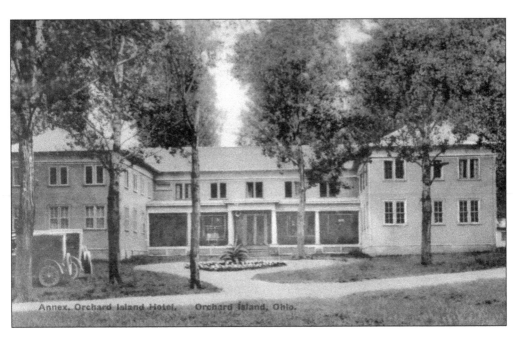

At some point before 1911, Rev. Alexander Tarr acquired Orchard Island and built a 50-room annex to the 100-room hotel to accommodate overflow crowds. By the late 1920s, Tarr was accused of mismanagement of the hotel. Rather than face a court battle, he sold the property to the Orchard Island Development Company for $350,000. The company, which was traded on the stock market as Orchard Island, Inc., started selling individual lots to interested customers. The Welcome Arch on Orchard Island Road was probably added in the early 1930s after Frank and Isabella Wicker acquired the property. Some of the buildings are visible in the background, but otherwise, the island remained very rural.

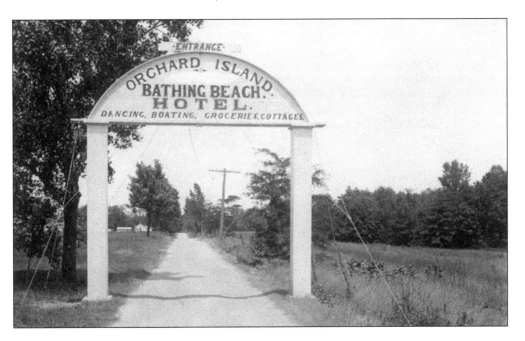

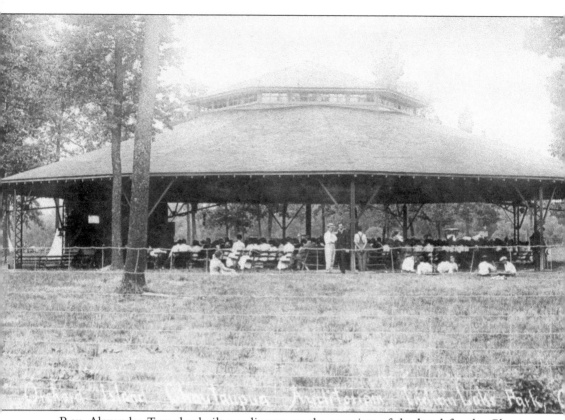

Rev. Alexander Tarr also built a coliseum on the premises of the hotel for the Chautauqua assemblies. These assemblies brought entertainment and culture to the community to stimulate and exercise the intellect. The meetings were held the last week of July and first week of August, and they drew huge crowds. In the summer of 1911, future president Warren Harding, who was editor of the *Marion Star* at the time, and William Jennings Bryan, who had lost his bid for the presidency three times, both came to Orchard Island and spoke at the Chautauqua. The coliseum was later converted into a skating rink. In the early 1990s, Jim Dicke, from the nearby town of New Bremen, purchased the hotel and coliseum. The coliseum was carefully dismantled, and each piece was marked before being transported by flatbed trucks to nearby New Bremen, where it was reassembled in the community park. The new coliseum does not include the enclosing walls (as shown on later postcards) but resembles the early open structure built on Orchard Island and shown in this postcard mailed in 1912.

Two

BIRTH OF VACATION LAND

The History of Logan County and Ohio, compiled by William H. Perrin and J.H. Battle and published in 1880, has the following to say about the Lewistown Reservoir: "Today one cannot well imagine anything more dismal and desolate than this spot, this vast submerged plain, thickly studded with the bare and darkly decaying trees, whose leafless branches spread abroad as if to warn the unwary of the dreadful miasma lurking below. Quinine ought certainly to be at a premium in the locality surrounding this cesspool of pestilence." Despite these ominous words, the State of Ohio created the Indian Lake State Park in 1898. With more leisure time, Ohioans began to seek out outdoor recreational opportunities, and resorts were developed on the shores of Indian Lake and other former canal feeder lakes.

Indian Lake had begun a new life as public park. Community amusement parks were built along electric railway lines as the park owners sought to boost weekend business. Indian Lake was among the first state parks when the park system was established. Around the lake, cottage parks sprang up where vacationers could find reasonably priced lodging and landings where boats were offered for rent. Most of these resorts had their own grocery and stores. *The Directory of Indian Lake* published in 1911 boasts that "no more delightful spot can be found for a day, a week, or a season's outing. Numerous hotels with pleasant rooms and surroundings and excellent cuisine provide desirable quarters at reasonable rates, either by the day, or by the week. For family parties furnished cottages may be rented ready for housekeeping, and, if desired, meals may be obtained at nearby hotels. For those that enjoy camp life, many beautiful sites are available along the shore of the lake or on the islands. Groceries, meats, provisions and household necessities are supplied by a number of stores, open the year round, that cater to the wants of the visitors." In a few short years, what used to be the destination of a select few had become a favorite place for people from all over the Midwest.

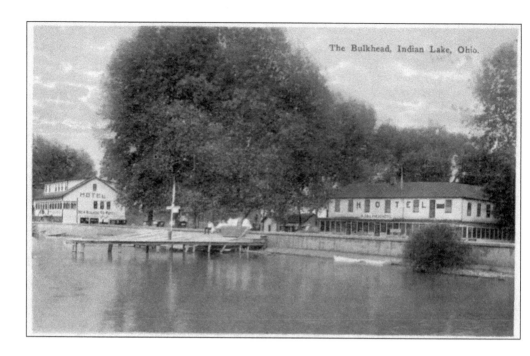

The Bulkhead, Indian Lake, Ohio.

The Hotel Bulkhead was located immediately west of the waste weir. The above card, which dates to before the 1920s, shows the old hotel on the left and the new hotel on the right. The hotel on the left was also known as the Smith Hotel, and the hotel on the right was first known as the National Hotel. The Hotel Bulkhead was torn down to make room for US Route 33, and a new hotel was built across the street on state-leased land. When the state discontinued the lease, the hotel and several neighboring cottages had to be torn down in 1985. This is the present-day location of the Whispering Valley Mobile Home Park.

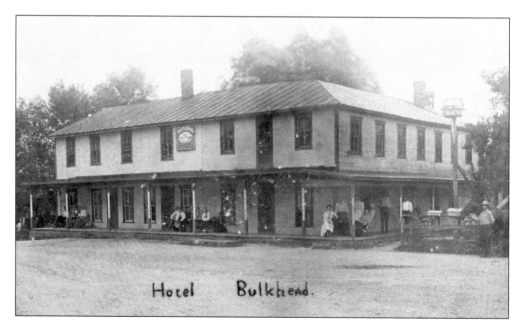

Hotel Bulkhead.

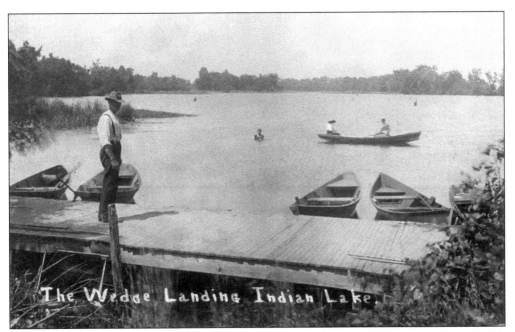

The Wedge Landing and Resort was a little farther west of the spillway and offered boat rentals and cottages for rent. The cottages were on the other side of the street.

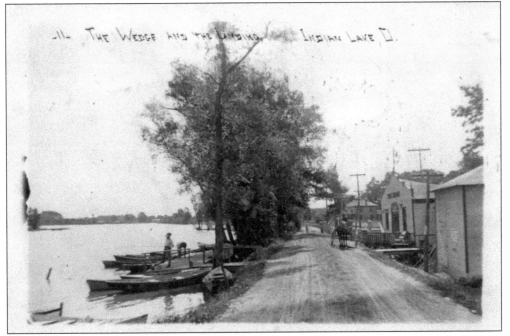

This is a view looking east from the Wedge Landing and Resort on a postcard dated 1913. In the distance, on the south side of the road, is the Hotel Bulkhead or National Hotel. The current lake wall had not yet been built.

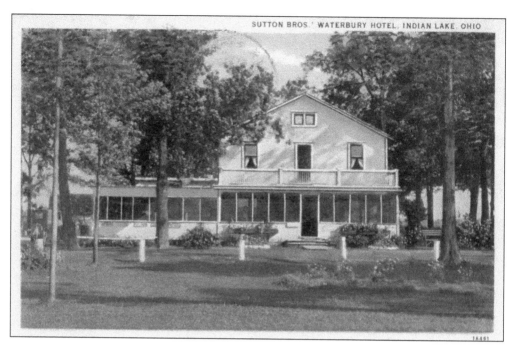

In 1910, Doc Waterbury purchased about 137 acres of land two miles east of Russells Point, on Waterbury Road, and built a hotel known as the Sunset Hotel. Waterbury also built 27 cottages, a grocery store, a boat landing, and a convention hall, later changing the business's name to Waterbury Hotel and Resort. Not long thereafter, brothers Roy and Cliff Sutton, from Xenia, purchased the entire complex, and the hotel was renamed the Sutton Brothers Waterbury Hotel. Roy's two sons had no interest in running the hotel, but his daughter Mildred later ran the hotel and resort.

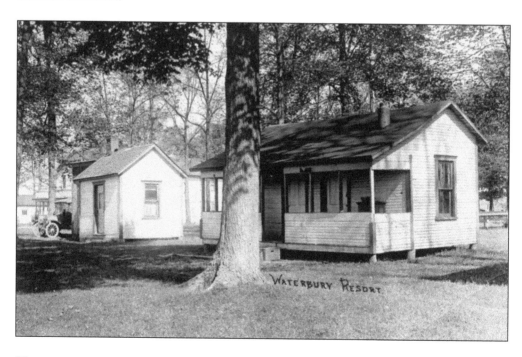

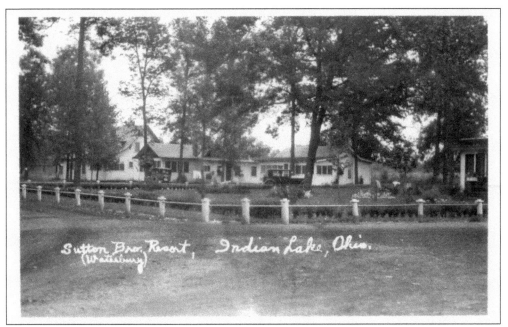

The Sutton Brothers Waterbury Resort included several cottages for rent to vacationers who traveled from near and far. Many of the vacationers arrived in automobiles, the new mode of transportation for upper- and middle-class travelers in the early years of the 20th century. The hotel burned down after being struck by lightning in 1924, and Mildred Sutton sold most of the property on Waterbury Road to "prominent persons representing all parts of the state who built summer homes on the Waterbury lots." The hotel and 22 cottages remained open as a resort for another four decades. The area between Dunn's Pond and the lake is now a mix of closely spaced homes and cabins—especially along the waterfront—and the Pirate's Cove Condominiums, consisting of 36 condominiums in seven buildings and constructed in 2007.

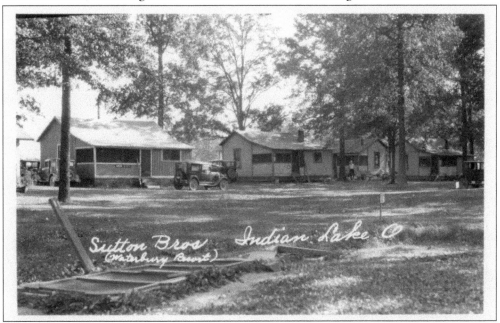

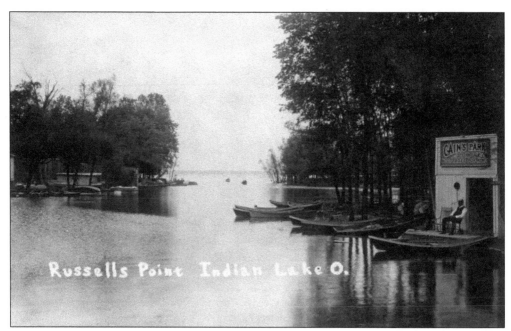

Russells Point Indian Lake O.

Cain's Park Landing was at the east side of the harbor near the entrance to the lake. Cain's Park, also sometimes called Siesta Park, was owned by Clayton Cain and had rowboats for rent, as well as six cottages. The lease on the land on the right was later purchased by French Wilgus, who built the Sandy Beach Amusement Park on this site.

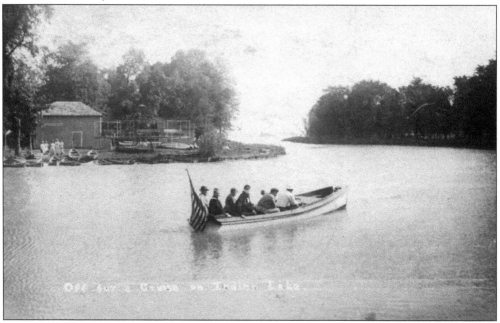

This postcard is postmarked July 28, 1920, and shows an early motorboat venturing out for a cruise on Indian Lake. By the time this picture was taken, the Russell farmhouse, located on the west side of the harbor, had been purchased by Morris Bundy and converted into a hotel and landing. Note the carousel in the background, an early indication of what was to become "Ohio's Million Dollar Playground."

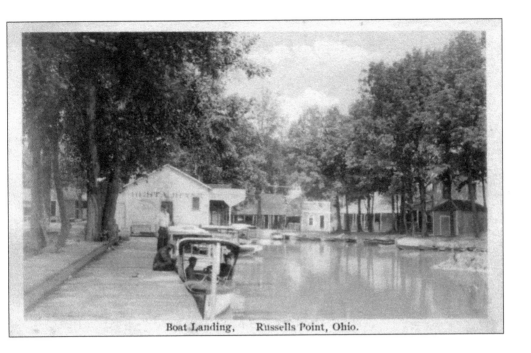

Boat Landing, Russells Point, Ohio.

The view in the above postcard is looking west toward the west shore of the harbor and public boat landing. The Busy Bee Restaurant is on the left. The first post office in Russells Point is in the center of the postcard. Harry Mansfield was the first postmaster, but he is better remembered as a prolific photographer who signed his photographs, many of which were reproduced as postcards, with "M." On the right is the Russells Point Hotel. The below postcard shows a closer view of the west side of the harbor.

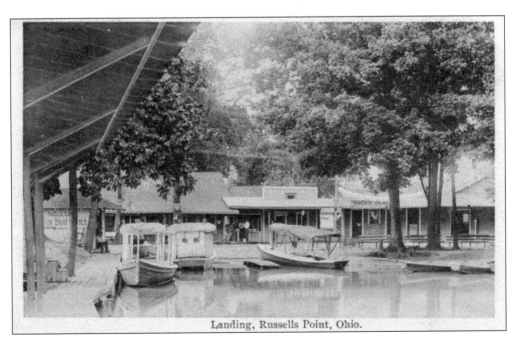

Landing, Russells Point, Ohio.

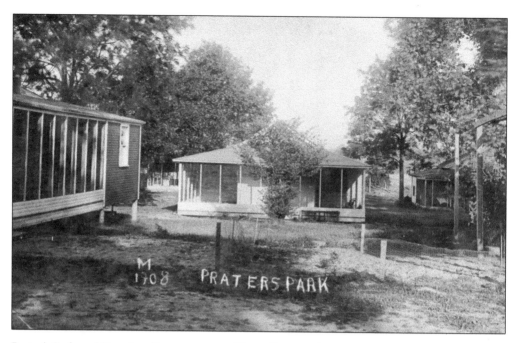

Prater's Park and Boat Landing was west of Russells Point harbor, on Wilgus Street, where Jac N Do's Pizza is now located. By 1908, when these photographs were taken, Salathiel Prater owned the largest group of cottages in Russells Point, with land containing 20 cottages, picnic grounds, and campgrounds. The name of the park was later changed to White Cottage Park, still owned by the Prater family. The landing was subsequently renamed Schlegel's Landing. Note how the men fishing are dressed in slacks and vest with the obligatory hat—a far cry from today's casual look. Silver Isle is visible on the left in the below postcard.

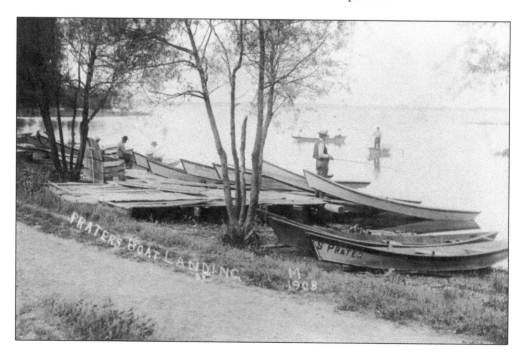

The cottages in this postcard are believed to be on Wilgus Street and part of Prater's Park (later called White Cottage Park). The pictures on this page, and on the previous page, were taken by Harry Mansfield, the prolific photographer who documented scenes around the lake and signed his photographs "M."

This postcard is postmarked August 8, 1907. The message on the back states: "Our cottage is next to this one. This is a fine place for boating and fishing." This was probably also on Wilgus Street. The sender of this card did not remark on the misspelled "Indiain Lake" on the front.

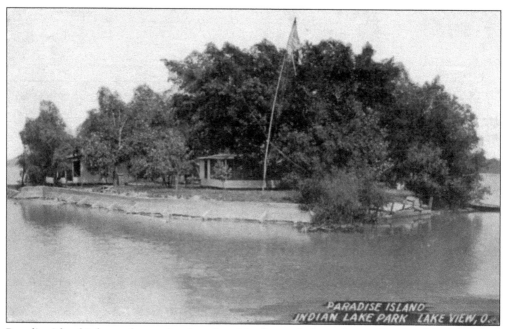

Paradise Island is located near the sharp bend in the road along the south side of the lake, west of Russells Point. The islet was initially named Whiteman Island after the owner/manager who operated six cottages and a boat landing on the island. Access was by boat only until a footbridge was built in 1915.

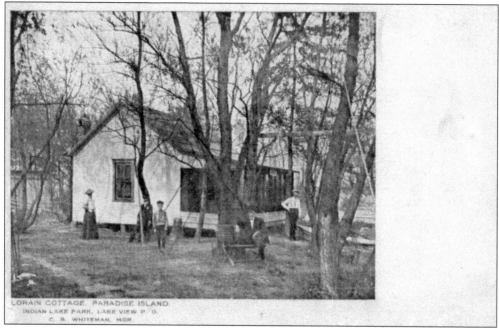

A family, all dressed in their best clothes, poses nonchalantly in front of one of the cottages on Paradise Island.

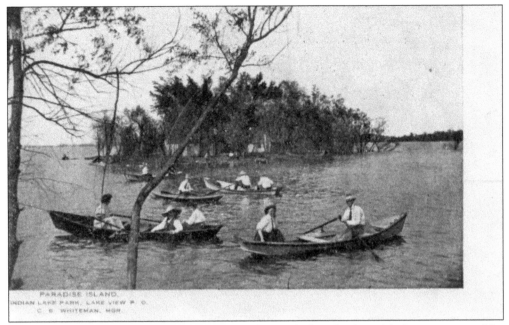

In addition to the cottages, Paradise Island also featured a boat landing. The boats were used for fishing and excursions on the lake as well as for traveling to and from the island.

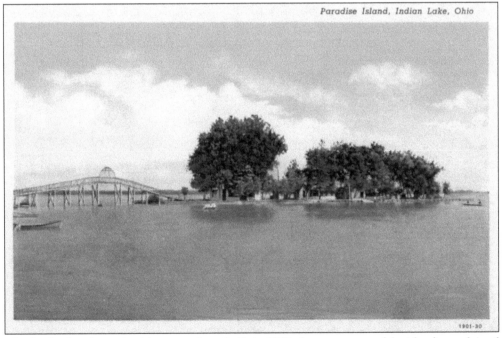

The footbridge shown in this postcard was built in 1915 after occupants of the island complained about having to row across the small channel several times each day. The bridge, which connected to the mainland at "The Bend," was built high enough to allow boats to pass underneath.

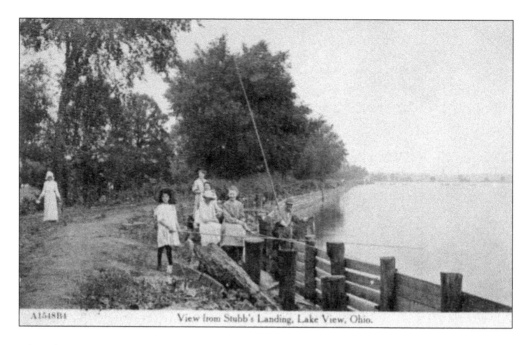

A1548B4 View from Stubb's Landing, Lake View, Ohio.

The wooden fence along Dyke Road, or Bank Road, between Russells Point and Lakeview, served to protect the shore from erosion, which was made worse as trees that were left standing when the Lewistown Reservoir was inundated died and washed up against the shore. Of course, the fact that the road ran right along the water also did not help with preventing shore erosion. The road was one of the favorite fishing places for locals and people who did not or would not go out on the lake to fish. For the men, catching fish in those times apparently required wearing a full suit, including a vest.

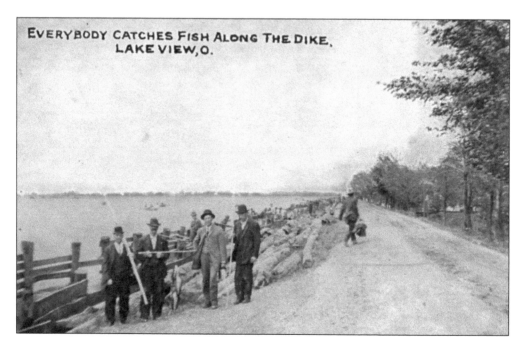

EVERYBODY CATCHES FISH ALONG THE DIKE, LAKE VIEW, O.

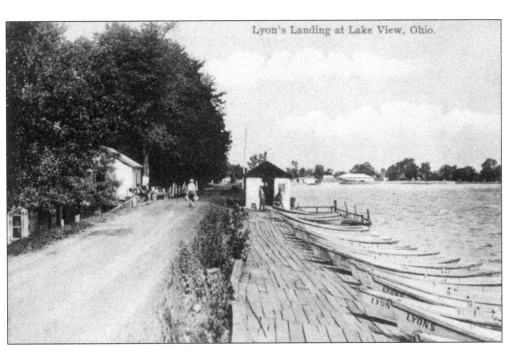

Lyon's Landing and Campground was owned by Captain Lyon and located a half mile east of Lakeview. At the landing, rowboats (and later motorboats) could be rented for the day. Before motorboats became a common sight on the lake, owners of landings used a motorized launch to tow vacationers in rowboats out to fishing grounds in the morning and pick up the anglers in the evening. Often, provisions for the day were purchased at the store also owned by Captain Lyon.

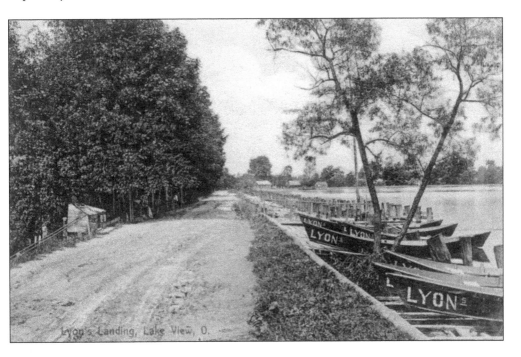

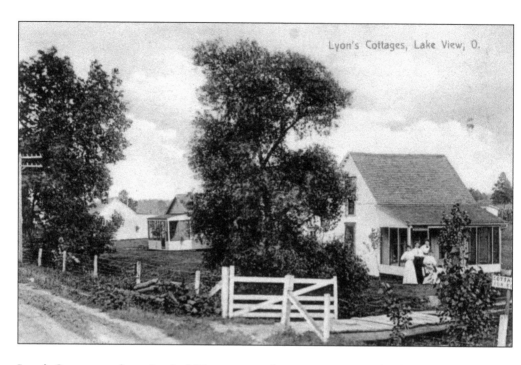

Lyon's Campground consisted of 25 cottages and a grocery store with a lunch counter on the south side of the Dyke Road and the boat landing on the north side, adjacent to the lake. Even by the standards of the early 20th century, some of the cottages were rather small, offering room for little more than a bed in which to sleep and a chair on which to sit. A few of the bigger cottages featured upstairs sleeping quarters. The cottage on the left in the below postcard appears to actually contain two separate tiny rental units.

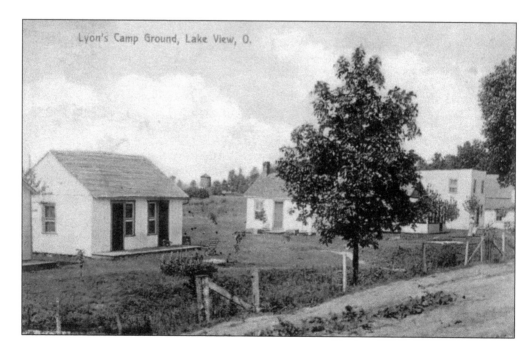

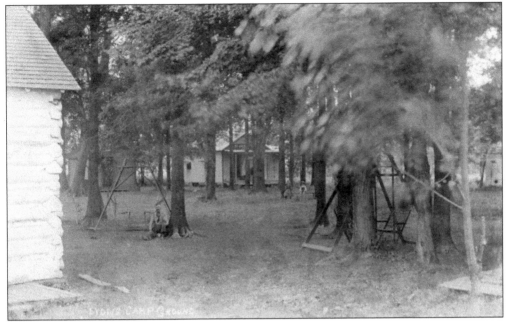

Lyon's Campground also featured a playground for children, as did most of the other campgrounds and resorts at the time. On most of the earlier postcards, no children can be seen playing, perhaps because taking a photograph required long exposure times. The small tree in the front must have moved in the wind while this picture was taken.

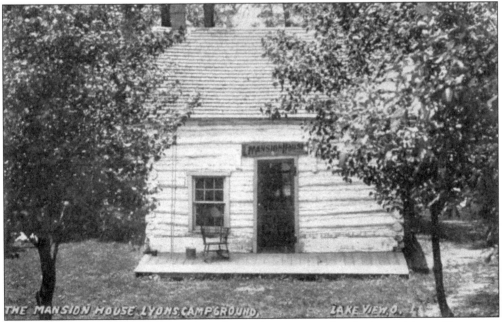

The term "Mansion House" may have been given tongue in cheek to this small cottage. Judging by the look of the building, this may have been an existing older cabin with clapboard siding that offered rather sparse accommodations to early visitors to the lake. The window and doorframe do not appear to be entirely square, which may have been caused by the lack of a foundation, which was common for cabins around the lake.

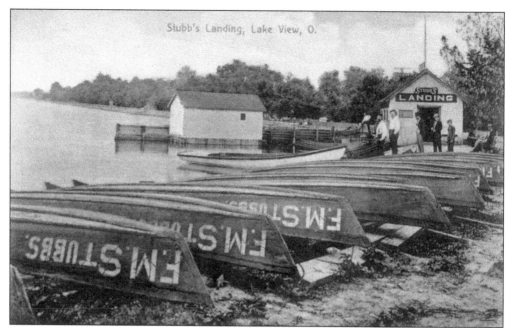

Stubb's Landing was located in Lakeview just east of where the lakeshore turns north. The landing was operated by Frank and Maggie Stubbs, who also owned the Stubb's Hotel in Lakeview and a campground with modern cottages. Although Frank's surname was "Stubbs," written correctly on the rowboats, all postcards referred to "Stubb's" Landing and "Stubb's" Cottages. Both of these postcards were posted in 1910, and the writers took the opportunity to let their families know that they were having "a grand time at the pond" and "a swell time." The landing offered the usual merchandise that vacationers might need when exploring the lake. In later years, the landing was owned by Emmett Bailey, who also owned a store on Lake Street in Lakeview.

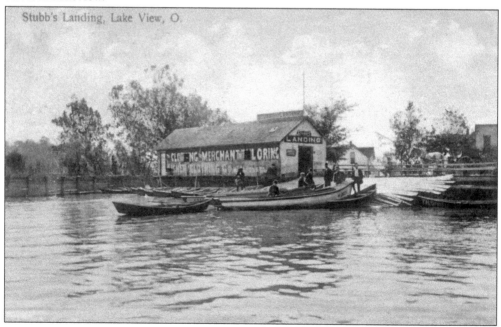

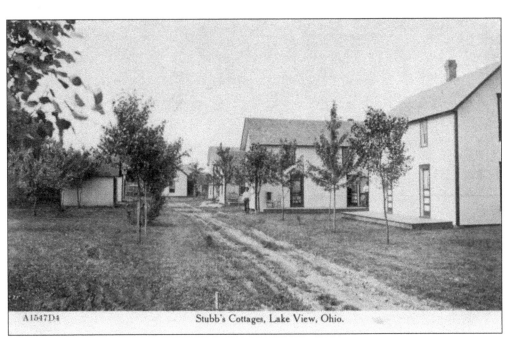

A1547D4 Stubb's Cottages, Lake View, Ohio.

Frank and Maggie Stubbs also owned ten cottages on the east side of Lakeview. Compared with the cottages at White Cottage Park and Lyon's Campground, those owned by the Stubbs were luxurious and modern-looking, without the "rustic look" so prevalent at the time. Most of the cottages featured a full second floor.

A SHADY NOOK IN
STUBB'S COTTAGE GROUND,
LAKE VIEW, O.

39

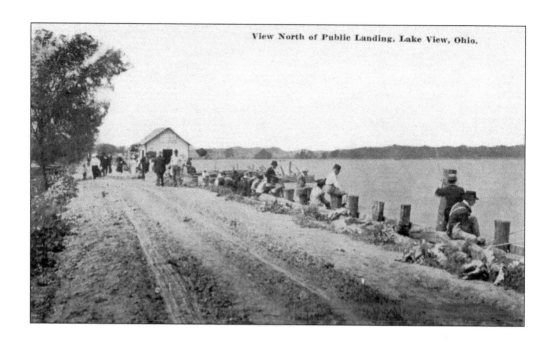

The landing and boathouse shown on the above postcard were owned by Jim Marshall and commonly known as Marshall's Landing. This landing was north of the Public Landing at Lakeview's Harbor, where the road along the lake turns northward—where Stevenson Street now joins State Route 235. The shore was a favorite fishing place. During the first decade of the 20th century, the roads—essentially dirt paths—were in poor condition and became virtually impassable after a heavy downpour. Road conditions did not improve until a new cement road was built in the early 1920s.

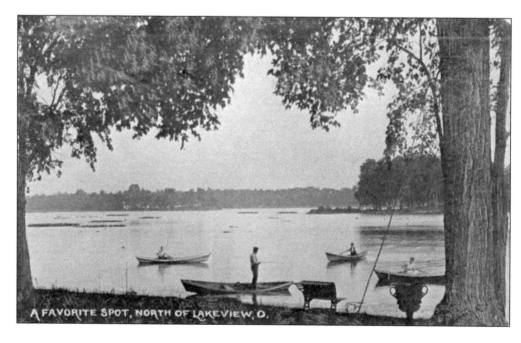

A FAVORITE SPOT, NORTH OF LAKEVIEW, O.

ASSAFRAS POINT

Cy Newland and his wife, Etta, established Newland's Resort around 1897 at Sassafras Point on the north shore of Indian Lake. This was the second resort on Indian Lake, and opened one year before the lake was designated a state park. The resort included some 30 guest cottages, a restaurant, a grocery store, a gas pump, an icehouse, and—of course—a landing with boats for rent. Cy planted many sassafras trees that came from North Carolina, because he loved the tea made from the tree's roots. *Sassafras albidum* is the main ingredient in traditional root beer and sassafras root tea; its use was banned by the FDA in 1960 due to health concerns about the carcinogenicity of safrole, a major constituent of sassafras oil. By that time, there was only one sassafras tree left on the point, carefully kept alive by the Newland family.

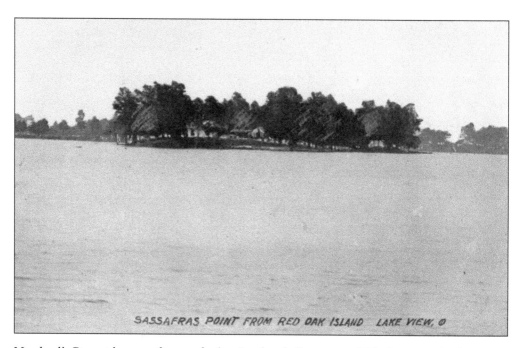

SASSAFRAS POINT FROM RED OAK ISLAND LAKE VIEW, O

Newland's Resort became famous for hosting baseball games, which drew people from near and far, including those who traveled by horse and buggy in the early days. After the death of their only son, Gene, owners Cy and Etta Newland sold off most of the point. Newland's Resort and Landing are still in operation and run by John Newland Jr., the great-grandson of Cy Newland. The current property consists of two waterfront cottages and a third one sitting on a hill overlooking the lake. In addition, many boat-related services and dock rentals are provided. Tent and RV camping are also available. Red Oak Island is one of several mostly uninhabited islands located just off Sassafras Point.

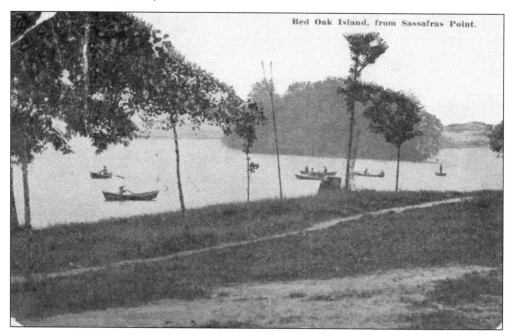

Red Oak Island, from Sassafras Point.

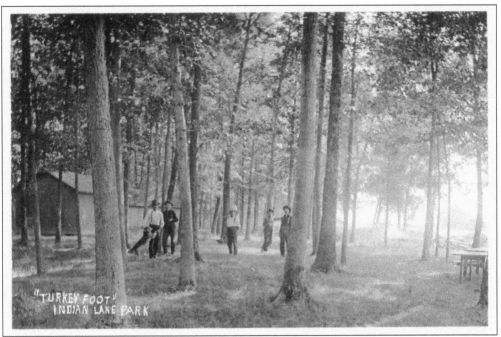

Turkey Foot Park, one of the oldest resorts on the north side of the lake, was located on a peninsula jutting into the lake and to the east of Sassafras Point. The proprietor was I.N. Buller, who operated a hotel, 50 cottages, a grocery store, a restaurant, and a boat landing. In the 1930s, Lou Hull and his wife took over the complex and built another 50 cottages, with most of them located on the waterfront. Turkey Foot Park was a popular place for hunting, with much of the peninsula covered by a dense growth of trees along with the occasional cottage and picnic table. The peninsula is now a densely developed area with cottages lining both sides of the main road.

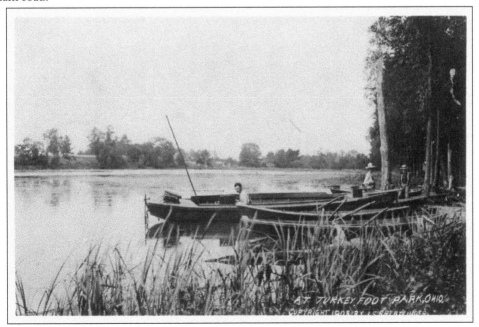

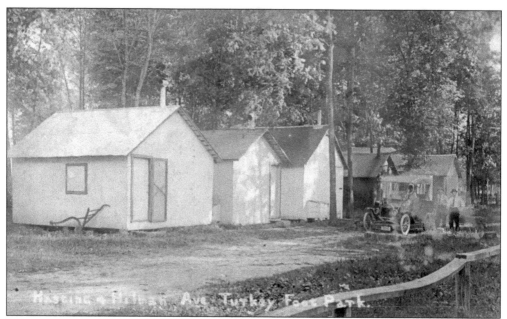

This postcard is dated August 11, 1911, and was mailed to Bernice Sautter in Marion, Ohio. On the back, "Ralph S." states that he got a "postal" (another term for postcard) with his car on it taken at Turkey Foot Park. The cabins at Hasting and Hilman Avenues are long gone, as are both avenues.

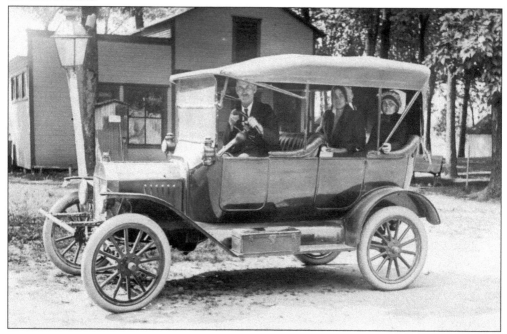

This personal postcard was made for Frank Thomas and his family. The picture was taken at Turkey Foot Park in front of the grocery store. One can only hope that Thomas was less cramped when driving than he appears to be in this picture. Given the date on the back of this photograph, August 21, 1916, Thomas must have been rather well-to-do, given that he was driving this shiny automobile around the lake at that time.

Three

"OHIO'S MILLION DOLLAR PLAYGROUND"

In the early 20th century, electric railways and other means of transportation made it easier for people to travel greater distances. Amusement parks sprang up around the state, and by 1912, there were more than 50 parks—with at least one in or around every major city as well as many smaller communities. At that time, the main tourist attractions at Indian Lake were concerts by national bands and sightseeing boats such as the *Evelyn*.

A local resident of Russells Point, Samuel "Pappy" Wilgus, and his son French Wilgus capitalized on the region's popularity and built the Sandy Beach Amusement Park, which opened to the public on May 29, 1924. Despite the Great Depression that began in 1929 and extended through the 1930s, the park flourished and soon became known as "Ohio's Million Dollar Playground" and the "Atlantic City of the West." Nationally known musicians played at the Minnewawa Dance Hall, while the park also offered a number of rides, a penny arcade, and other types of entertainment. Visitors could also walk along a boardwalk to Sandy Beach Island for swimming.

The dance hall and parts of a number of rides were destroyed by fire in 1935 after the summer season had ended. This could have meant the end for the Sandy Beach Amusement Park, but the new owners, Charles Horvath and Louis Greiner, rebuilt the park. The Moonlight Terrace Gardens replaced the old Minnewawa Dance Hall, and the park continued to draw large crowds. When Ohio celebrated its sesquicentennial in 1953, approximately 100,000 people traveled to the area. Local businesses that relied on tourism continued to prosper throughout the 1950s.

In the 1960s, the success of Sandy Beach Amusement Park—then called the San Juan Resort—was challenged. On July 4, 1961, a riot broke out in Russells Point. For the next decade, riots continued to erupt every year during the Fourth of July holiday weekend. These riots caused significant financial damage to local businesses and hurt the amusement park's reputation. In an effort to change the tide, the park was renamed the Indian Lake Playground, but this hardly improved the park's fortunes. Attendance figures continued to drop, and the park was closed in the 1970s.

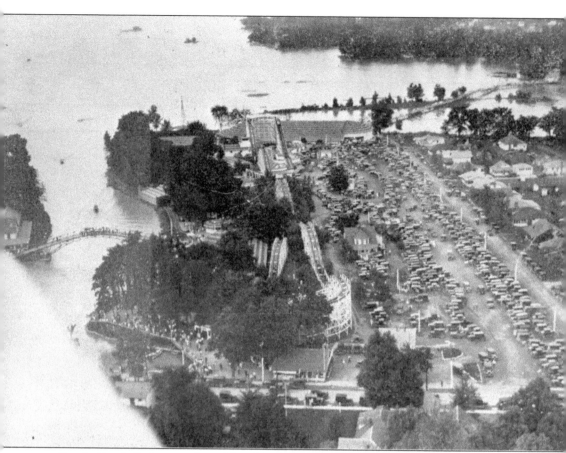

Sandy Beach Park opened on May 30, 1924. The summer before, Samuel "Pappy" Wilgus and his son French Wilgus had acquired the lease to the Caine property on the east side of the harbor and announced that they were going to build an amusement park. Five years earlier, Samuel Wilgus had established the Sandy Beach bathing area on a small island, about 50 yards from the mainland, that was only accessible by boat. The first order of business was to build a one-mile-long boardwalk starting at Main Street and going all the way back to the lake edge; here, a walking bridge connected to Sandy Beach Island. It looks like a second bridge connected the Beach Island to Orchard Island in the upper-right corner of the photograph. In the center of the photograph is the Minnewawa Dance Hall, which burned to the ground two weeks after Labor Day in 1935. The roller coaster extended over almost a half mile alongside the harbor. Note the many cars parked along Chase Avenue.

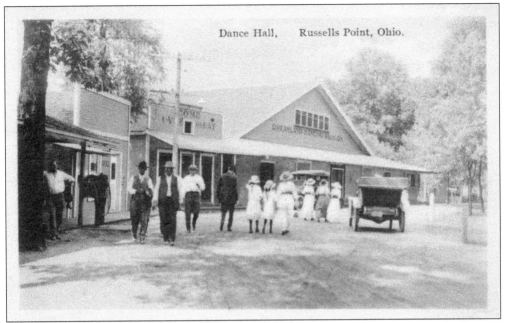

In 1911, A.B. Jones purchased Morris Bundy's Resort on the west side of the harbor in Russells Point and enlarged the hotel; he also constructed a grocery store and a post office that was only open during the summer. Jones also built the first dance hall in the area, the Dreamland Dancing Pavilion.

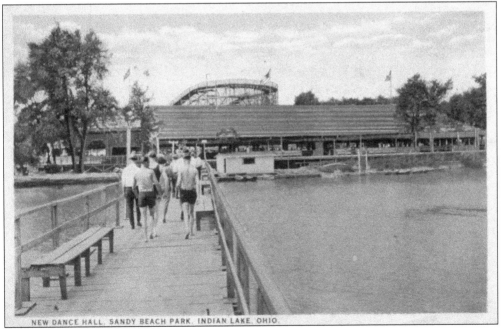

This is the footbridge going south from Sandy Beach to the amusement park and the New Dance Hall on the mainland. The roller coaster towers above the dance hall. Before this footbridge was built, vacationers had to take an excursion boat to Sandy Beach Island.

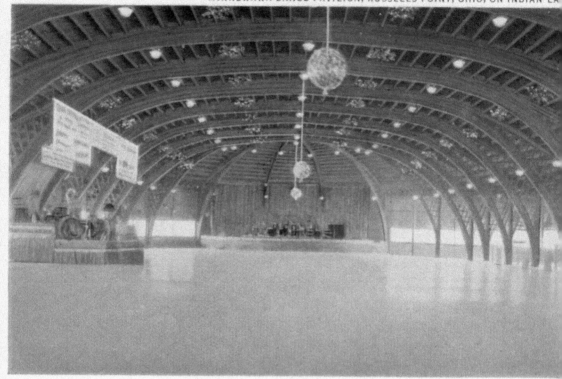

The Minnewawa Dance Hall was built in 1923–1924 by Elmer Katzmeyer at a cost of $50,000. With its length of 262 feet and width of 82 feet, it was one of the largest dance halls in the state. The roof was supported by laminated arches, each prominently displaying the name of a city or town to facilitate tourists being able to find one another at the arch for their town. On many nights, two bands would play, alternating after a few songs each. On Saturday, September 21, 1935, a spectacular fire raged across the Sandy Beach Amusement Park, destroying the large dance hall and burning practically all nearby concessions. The flames started in the northeast corner of the dance pavilion at 9:15 p.m. and quickly engulfed the dance hall, which had been remodeled just the past summer, as well as several rides, including the Old Mill and roller coaster. The dance hall had been closed since Labor Day, two weeks before the fire erupted. A crowd of more than 10,000 spectators watched the fire, the cause of which remains a mystery.

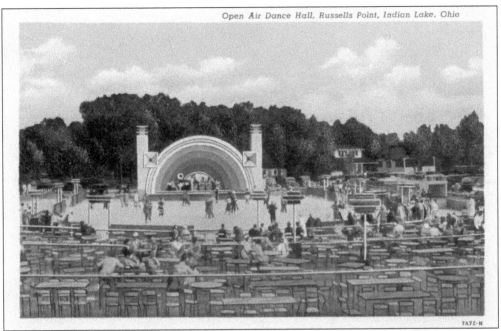

Open Air Dance Hall, Russells Point, Indian Lake, Ohio

Following the fire in 1935, the Wilgus family sold their interests in the Sandy Beach Amusement Park but retained the Spa Swimming Pool. Perhaps they were discouraged from rebuilding after the insurance only paid for approximately half of the total damages. The Moonlight Terrace Gardens occupied the same spot as the dance hall that burned down and was built in 1936 by the new owners of the amusement park, Charles Horvath and Louis Greiner. The area in front of the stage had plenty of room for dancers, while seats offered solace for more sedative crowds. The dance hall had a cement band shell and was terraced at one end for tables. Many big bands played the venue, but summer rains often resulted in cancellations.

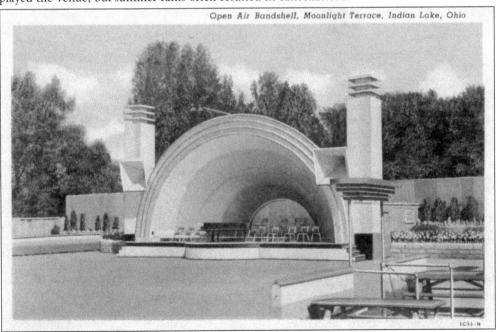

Open Air Bandshell, Moonlight Terrace, Indian Lake, Ohio

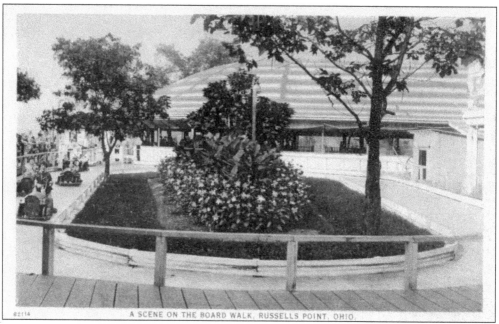

A SCENE ON THE BOARD WALK, RUSSELLS POINT, OHIO

Here is a view of the boardwalk at the "race car track." The Minnewawa Dance Pavilion is in the background. It is likely that this is part of the boardwalk that also burned during the blaze of 1935.

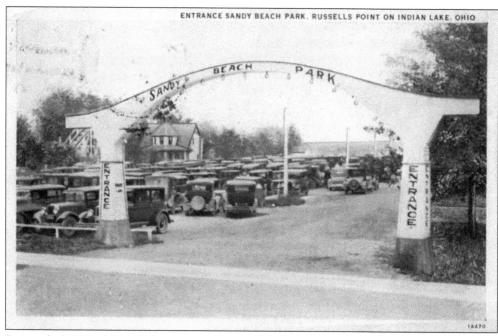

ENTRANCE SANDY BEACH PARK, RUSSELLS POINT ON INDIAN LAKE, OHIO

Postmarked 1931, this card shows the arch spanning the entrance to Sandy Beach Amusement Park at the corner of Main Street and Chase Avenue. The archway was removed not long after this photograph was taken in order to allow rides to enter the amusement park. Of particular interest are the large number of similar looking automobiles; the driver would have to pay particular attention to where he parked his car so that he could find it in this sea of Fords.

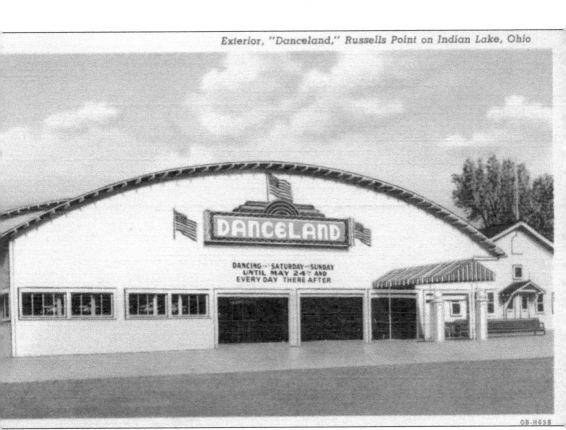

During the Depression, dance marathons became very popular for participants and spectators alike. Couples danced almost nonstop for hundreds of hours in competition for prize money. These events reflected the sense of desperation that Americans endured during the Great Depression. Contestants were guaranteed a roof over their heads and plentiful food—both scarce commodities in the 1930s. In return, the couples had to dance for 45 minutes out of every hour around the clock. These degrading events were rigorous but also rigged. The mix of amateur and professional couples endured increasingly brutal demands as time went on, such as eliminating the 15-minute breaks, just to keep the paying public entertained. In 1931, the National Endurance Dance Marathon was held in the Marathon Ballroom, built specifically by promoters for this purpose on the site the amusement park. The marathon lasted for an astonishing 80 days and 2 hours (two and a half months!). Mary Rock Fite, from Chicago, and a local fellow from Russells Point named Charles Murray were the winners of the 1931 dance marathon. After the marathon craze died down in the mid-1930s, the building on the site of the amusement park was closed and returned to the Wilgus family. The building was moved to the other side of the harbor and operated by the Wilgus family under the name Danceland.

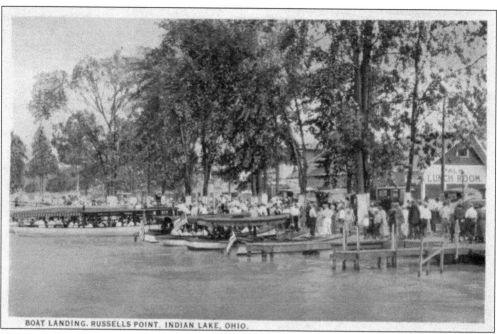

This view from the early 1920s of the Russells Point Harbor shows many sightseeing boats. The Palm Lunch Room was operated by Tess McCann and was on the south side of Main Street.

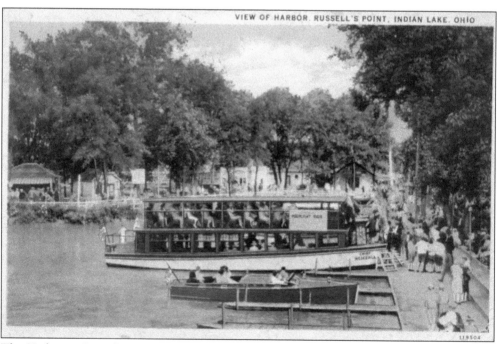

The Harbor at Russells Point is pictured here with the *Chief Weseeall* sightseeing boat at the docks. The name of the boat was shortened to the *Chief* before the vessel was replaced by the stern-wheeler *Mark Twain* in the late 1950s. In the background are various concession stands and attractions of Sandy Beach Amusement Park.

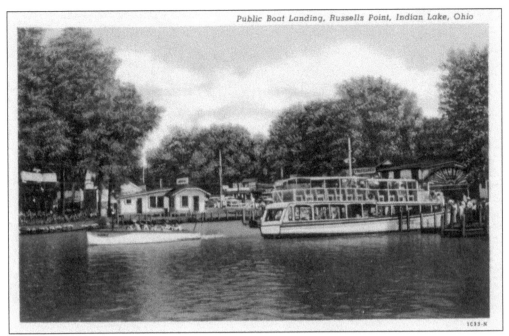

Here is another view of the harbor with the double-decked excursion boat known as the *Chief*. The white building in the center is the State Office located on Main Street.

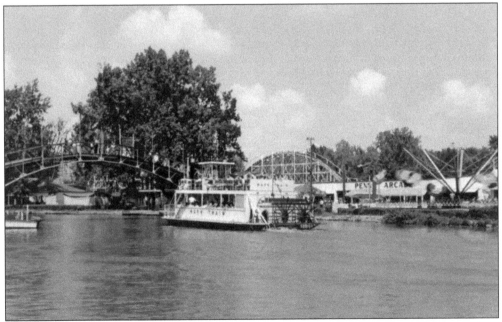

This postcard from the early 1960s shows the stern-wheeler *Mark Twain* excursion boat approaching the steel bridge that spanned the harbor. By this time, the amusement park was called the San Juan Resort and was owned by George Quatman, who continued to make significant investments in the park.

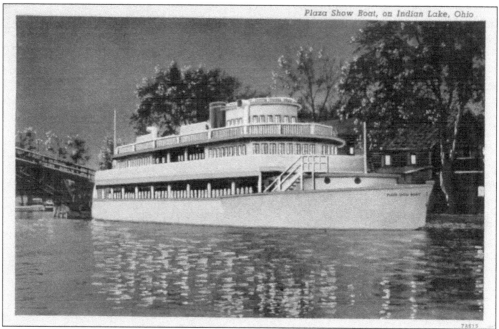

The *Plaza Show Boat* was designed by Nathan Coon for French Wilgus and opened in 1936. It was 104 feet long and 30 feet wide and could accommodate 600 guests. The main deck consisted of a large dining area with a large dancing area in the middle. More dining space could be found on the second deck, while the third deck accommodated an office area and space for small private parties. Surrounding the main deck was an open-air promenade with chairs and tables for patrons to overlook the harbor. The boat's appearance, complete with pilothouse, masts, and smokestacks, gave the impression of a tall yacht ready to sail to distant ports, but the *Plaza Show Boat* was actually permanently moored on the west side of Russells Point Harbor just north of the footbridge. At the Speed Ride docks, passengers could embark for a speedboat ride around the lake.

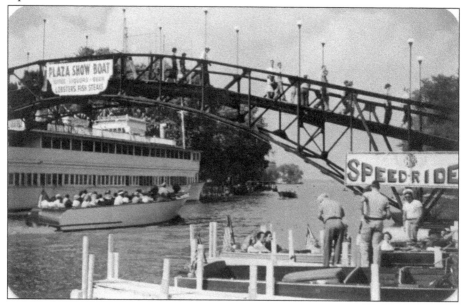

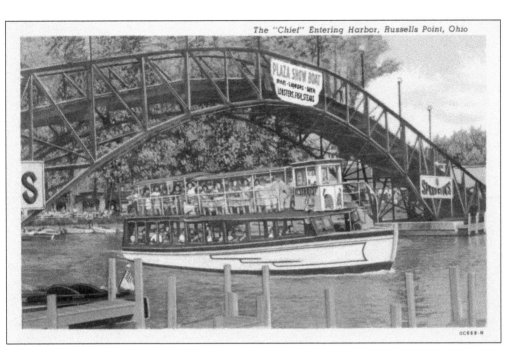

Russells Point Harbor was the hub of activity and action around Indian Lake. From the public landing, many excursion boats departed to take visitors and vacationers across the lake or to one of the swimming beaches. Besides the *Chief* and the *Evelyn*, there were many other tour boats. During the 1930s, 13 pleasure boats and 17 speedboats operated from the harbor.

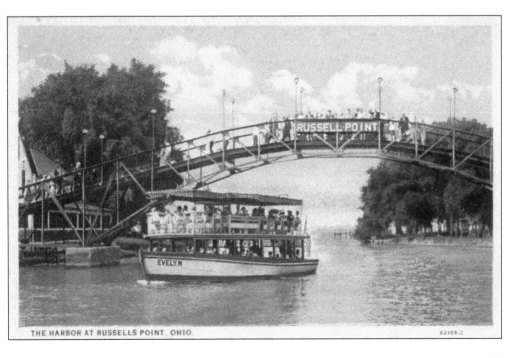

THE HARBOR AT RUSSELLS POINT, OHIO.

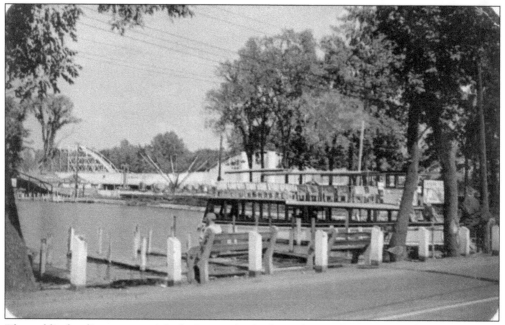

The public landing, or municipal pier, at the harbor of Russells Point—with a view of the Sandy Beach Amusement Park—was part of Indian Lake's "Million Dollar Playground." The excursion boat the *Chief* is moored at the dock, with the chairs on the upper deck ready for another crowd of sightseers.

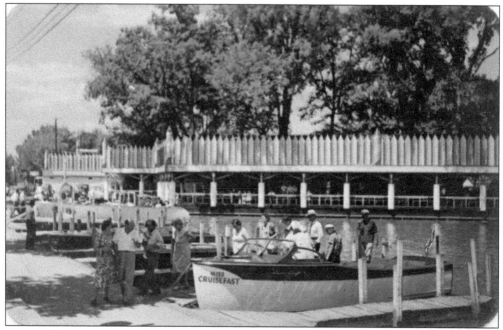

A view of the harbor at Russells Point looks toward the boardwalk and the Old Vienna Gardens on the western shore. The motorboat *Miss Cruisefast* was owned by Henry Blum, who owned several speedboats.

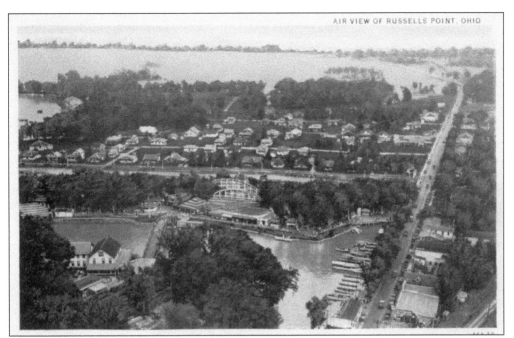

This aerial view looks east across the harbor. The building in the lower left corner is the Hotel Russells Point; to the right of the hotel is the footbridge leading to the roller coaster and boardwalk of the amusement park. In the lower right is the public landing. In the upper right corner, the road curves along the spillway, with the fish hatchery and the Great Miami River to the right of the road.

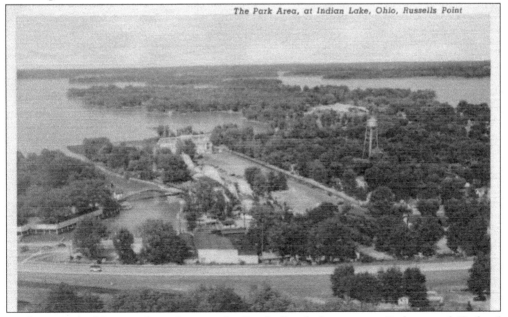

The Park Area, at Indian Lake, Ohio, Russells Point

In this view looking northward across the Sandy Beach Amusement Park toward Orchard Island in the back, the new Highway 33 runs east to west in the foreground. The building on the west side of the harbor is the Old Vienna Gardens, which was widely known for its floor shows and vaudeville acts.

57

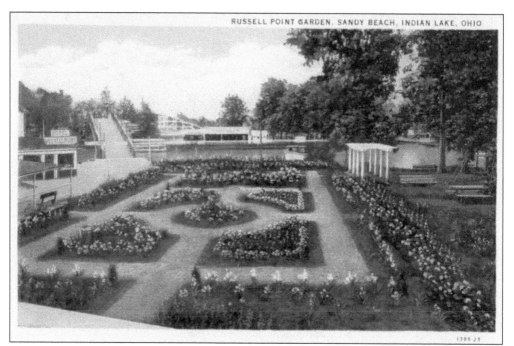

This postcard offers a view of a formal garden across from the Hotel Russell Point, with the footbridge across the harbor and Sandy Beach Amusement Park in the background. This postcard dates from earlier than 1933, as the sign on the hotel reads "Hotel Russell Point."

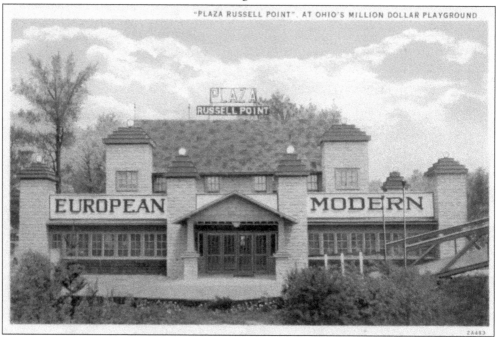

"PLAZA RUSSELL POINT", AT OHIO'S MILLION DOLLAR PLAYGROUND

John Marshall first named this the Hotel Russell Point. It was enlarged and operated by Jack Beatley until the Wilgus family acquired the leases to the west side of the harbor in 1933 and renamed the hotel The Plaza. In December 1956, George Quatman purchased the lodging and renamed it the San Juan Hotel.

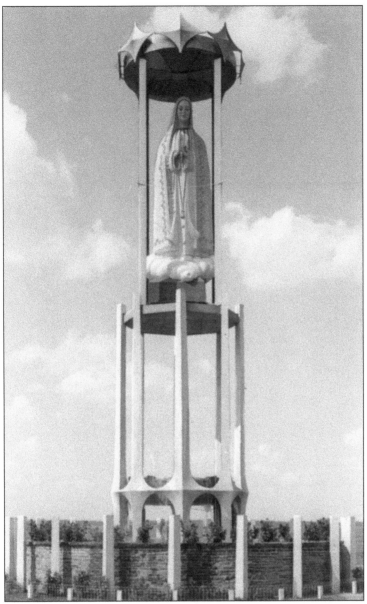

In 1958, George Quatman became owner of the Sandy Beach Amusement Park, renaming it the San Juan Park. Quatman, a telephone company owner from Lima, had previously purchased the properties on the west side of the harbor, including the hotel. Both sides together now constituted the San Juan Resort. Quatman was a devout Catholic who did not permit alcoholic beverages to be sold on the premises of the resort. In 1963, he had a statue of Our Lady of Fatima erected in the park. The statue was nineteen feet, six inches tall and was sculpted and then cast out of fiberglass in Florida. Upon completion, the statue was shipped to Ohio and mounted atop a concrete pedestal twenty-three feet, six inches high. Mary's robes were painted blue and white, trimmed in gold, with fluorescent paint that came alive under controlled black lighting. The statue included 14 changes of fountain scenes and 18 changes of color. It was dedicated in August 1964 and is the only surviving artifact of the San Juan Park. Quatman passed away one month after the dedication of the statue.

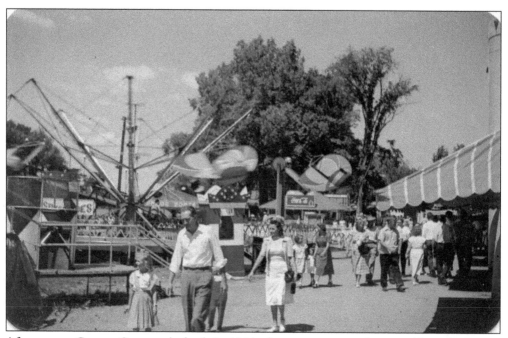

After owner George Quatman's death in 1964, the amusement park was sold to the Venice Amusement Company, with Tony Guilliano appointed manager. The park was renamed Indian Lake Playland Park and was geared more toward families, with reduced prices for the rides to accommodate family budgets. Big bands continued playing the park. Despite continuing to attract families, the Indian Lake Playland Park gradually went into decline and closed in the mid-1970s.

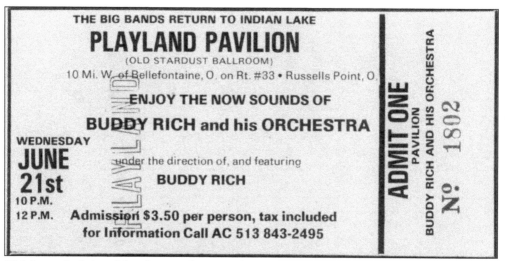

This is an admission ticket for a performance by Buddy Rich and his Orchestra in the Playland Pavilion, formerly the Stardust Ballroom and the Danceland Ballroom. It is not clear whether this ticket was valid for the 10:00 p.m. show, the 12:00 p.m. show, or both.

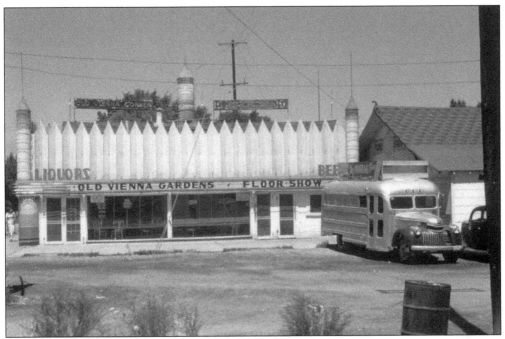

The Old Vienna Gardens was located at the site of the Dreamland Ballroom. After the building was enlarged and the name changed, nightly vaudeville and music shows were presented every night that the amusement park was open. In its heyday, the shows were advertised as having fifty people on the program, including eighteen girls in the chorus line and a fourteen-piece orchestra.

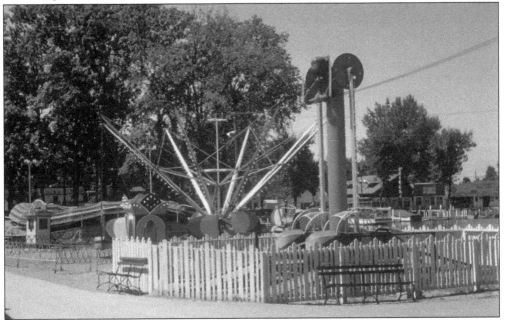

The ride shown in this photograph taken during the 1960s provided entertainment for the children. Perhaps this photograph was taken in the early morning hours, because it does not show the crowds of people who usually visited the amusement park.

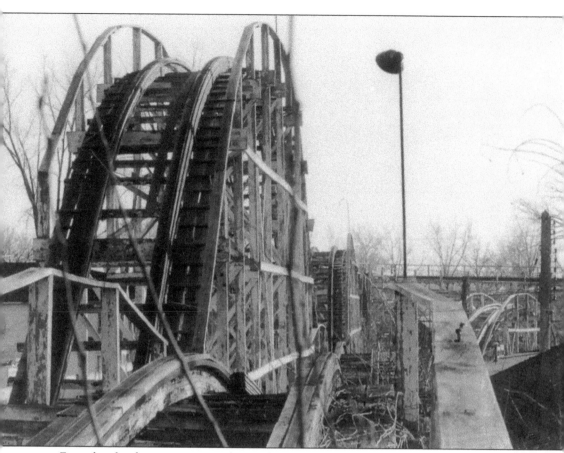

For a decade, the amusement park was plagued by annual riots on the Fourth of July weekend. On July 5, 1961, the first riots started shortly after midnight when a group of young people began fighting and throwing tables around in a beer garden. The crowd, which was estimated at between 400 and 1,000 people, blocked off Main Street in Russells Point. The demonstrations finally ended around 2:30 a.m. with the arrival of 20 Ohio patrolmen and a drenching by fire hoses. According to the mayor, Gene Gooding, there did not seems to be any particular ringleaders, and this seemed "just a case of a lot of young fellows with nothing better to do." It was not until 1972 that Russells Point experienced a peaceful Independence Day celebration. By then, however, the gradual decline of the amusement park had already started, and the park was permanently closed in the mid-1970s. It sat abandoned for several years until the grounds were purchased by William Reed. Reed organized a Destruction Party on August 14, 1981, at which people were allowed to take whatever few pieces were left.

Four

HOTELS AND RESORTS

As the numbers of visitors to Indian Lake increased, so did the demand for lodging. Hotels and resorts sprang up around the lake, offering a range of accommodations ranging from simple cabins to luxurious hotels. As early as 1911, the *Directory of Indian Lake* listed 11 hotels and 12 resorts. Some of the better-known hotels, such as Beatley's Hotel, the Wicker Hotel, and O'Connor's Landing, also offered cottages for rent in addition to private beaches for use by their guests.

An unknown number of cottage parks were in operation, with lodging options ranging from a few cabins for rent to large resorts such as Newland's Resort and White Cottage Park. Often, the name of the park was changed when new owners took over, making it difficult—if not impossible—to take an accurate count of how many sprang up over the years. Sometimes, the name was changed for no apparent reason, as was the case of Prater's Park, which was renamed White Cottage Park although it remained under the ownership of Salathiel Prater. As many as 60 or more cottage parks existed throughout the history of Indian Lake. Today, fewer than a half-dozen resorts remain.

The larger hotels closed after the demise of the amusement park due to lack of guests, or because the original owner passed away, or because the hotel was destroyed by fire. Only one motel is still in existence: the Villa Motel in Lakeview. Otherwise, the closest lodgings are in Bellefontaine, some 10 miles east of the lake on US Highway 33. A few cabins remain available for rent, and there are several campgrounds around the lake that can accommodate visitors provided they bring their own sleeping quarters.

A complete overview of all the hotels and resorts of Indian Lake is impossible within the limited number of pages allotted here. What follows is a selection based on available postcards.

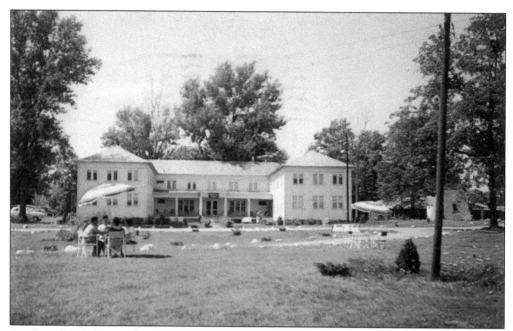

Frank and Isabella Wicker purchased the 100-room hotel and the 50-room hotel annex on Orchard Island in 1932. The main hotel had fallen into disrepair as the Great Depression reduced the number of guests, and the Wickers had it torn down. They continued operating the Annex, which became known as the Wicker Hotel, as well as the cottages and the grocery store, and they converted the coliseum into a roller rink.

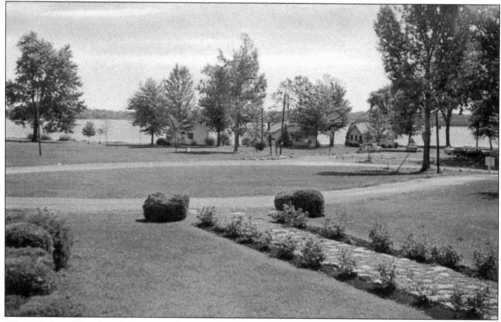

The Wicker Hotel and Resort advertised itself as Indian Lake's complete vacation spot, with a beautifully landscaped waterfront, private beach, modern waterfront cottages, boat docks, restaurant, and bar. Families from around the country visited and enjoyed the privacy afforded by the property and its beach.

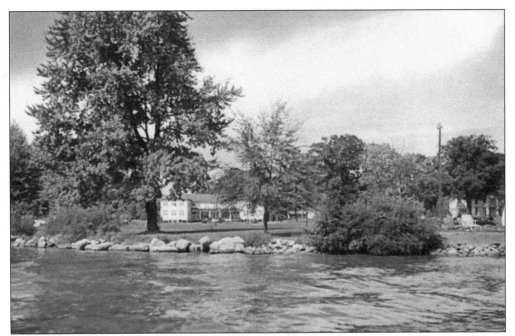

The Wicker Hotel and Resort occupied the northwest corner of Orchard Island overlooking the lake. This view shows the hotel as seen from the lake. The hotel was remodeled in 1950. Three more cottages were built in the 1960s.

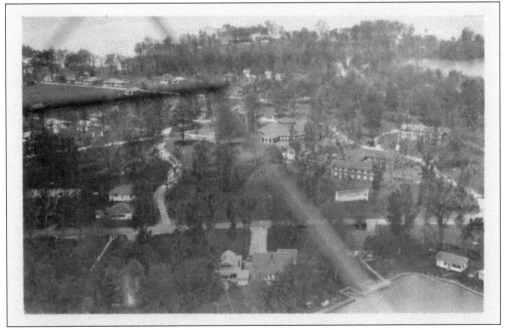

This aerial view of Orchard Island looks in the southwest direction. The coliseum is in the center of the photograph; the U-shaped hotel is to the right and behind what appears to be a large billboard. Near the waterfront, in the lower right corner, is one of the cottages belonging to the resort. The blurry line extending diagonally across the photograph was caused by the bracing of the airplane interfering with the picture being taken.

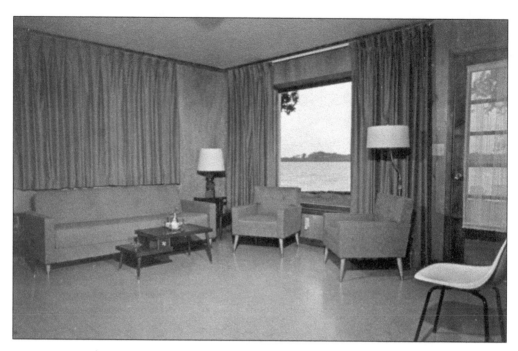

These postcards feature interior views of the cottages at the Wicker Resort. The above postcard shows a partial view of a beautiful and spacious living room in one of the ultramodern waterfront cottages, and the below postcard shows a partial view of a compact yet spacious bedroom. The wall-to-wall wood paneling, the unpainted wooden doors, and the linoleum floors were the typical cottage look in the 1950s and 1960s. Although it is not visible on these black-and-white reproductions, the tan-colored furniture with matching curtains and modern table and lamps complemented the mid-century look.

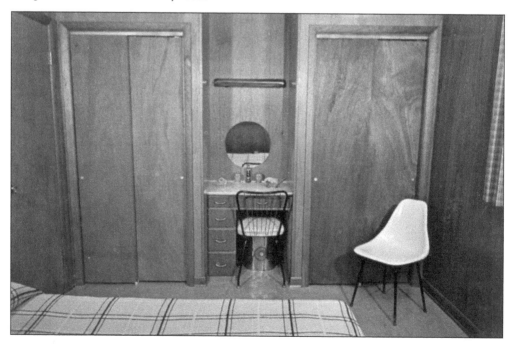

Frank Wicker passed away in 1939. His wife, Isabella, continued operating the resort. In the early 1940s, she added an L-shaped attachment to the grocery store to serve as a dining facility for guests. The hotel was renovated in 1950, and in the 1960s, three more cottages were added. In 1979, Isabella Wicker's private residence was destroyed by fire. She passed away in 1989, 50 years after her husband died. Family members continued to operate the resort for some years but ultimately closed the entire resort in the early 1990s. Jim Dicke, owner of the Crown Equipment Corporation in New Bremen, purchased the property and had the buildings razed and the land returned to its natural state, in which it remains to this day. The only buildings that survived are the coliseum, which was dismantled and rebuilt in New Bremen, and the original Orchard Island Post Office, which was in use from 1912 until 1926. The post office building was donated to the Indian Lake Area Historical Society by the Wicker family. After restoration, the post office was relocated to Dredge Island, or Post Office Island, between Orchard and Wolf Islands.

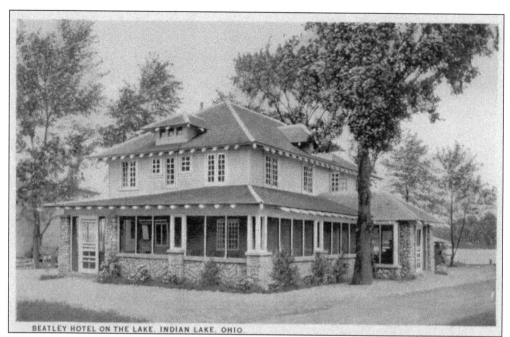

BEATLEY HOTEL ON THE LAKE. INDIAN LAKE. OHIO

Jack Beatley came to Russells Point in 1914. He met Lillian Krouskop, who was in charge of the post office, and they were married shortly thereafter. At first, Jack managed the Hotel Russells Point and took care of delivering ice. In 1921, Jack built his own hotel at what is now Holiday Shore, just south of the bridge to Orchard Island. The initial hotel, shown in this postcard, had only 10 rooms.

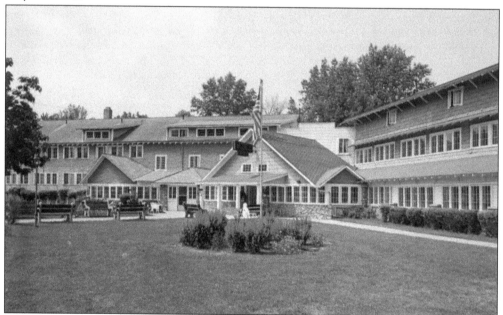

Jack Beatley and his wife, Lillian, continued to expand the hotel, which was only open during the summer months. By 1927, the hotel had 76 guest rooms. The Beatleys spent the winter in Miami Beach, where Lillian got ideas for improving the hotel and adding new features such as neon and fluorescent lights.

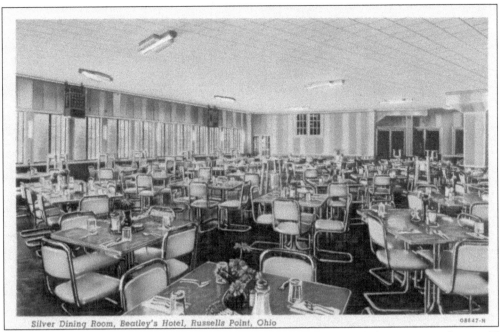

Silver Dining Room, Beatley's Hotel, Russells Point, Ohio 0847-N

Soon after the Beatley Hotel opened, Jack Beatley added a bar and dining room that could seat up to 200 people. He continued enlarging the dining room to accommodate more than 300 guests.

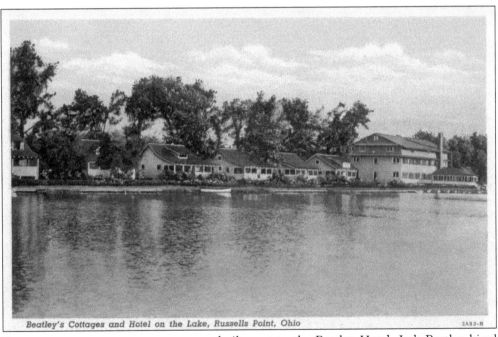

Beatley's Cottages and Hotel on the Lake, Russells Point, Ohio 3A93-N

Twenty-seven two-story cottages were built next to the Beatley Hotel. Jack Beatley hired mostly college students to work at the resort. To accommodate these temporary employees, he built a dorm for the female waitresses and a separate round house for the men.

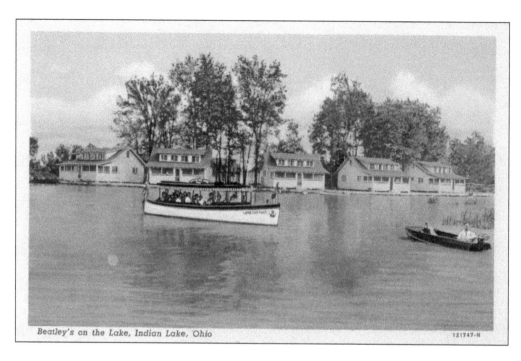

Beatley's on the Lake, Indian Lake, Ohio

The Beatley Hotel continued to prosper into the early 1970s, but Jack Beatley Jr. got tired of the hotel and resort business, perhaps also because the amusement park had closed and business had declined. All the buildings were demolished, starting with the dorm for the female summer employees. By the end of 1972, the main hotel had been torn down, and the land was turned into a mobile home park. A public auction of the contents of the hotel was held the weekend of September 23 and 24, 1972.

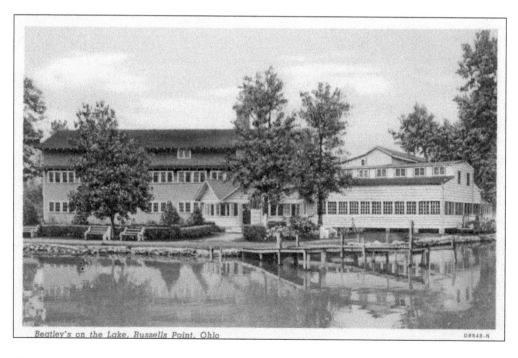

Beatley's on the Lake, Russells Point, Ohio

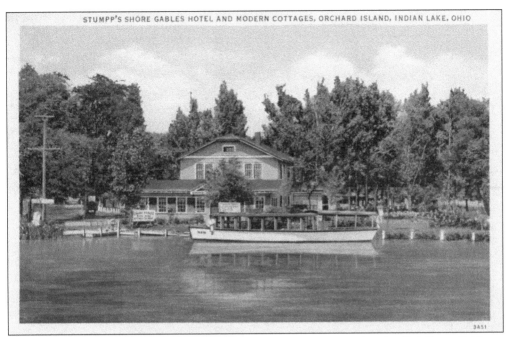

In the midst of the Great Depression, Karl Stumpp built a 15-room hotel called Shore Gables, a handful of cottages, and a boat landing. Stumpp added a grocery store, where he sold camping and fishing supplies in addition to groceries. Ultimately, the hotel was converted to apartments before it was torn down in the 1990s.

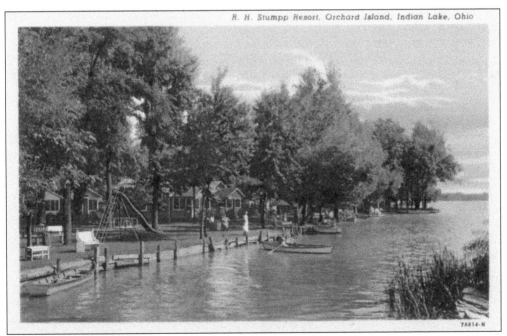

R. H. Stumpp Resort, Orchard Island, Indian Lake, Ohio

This view of the waterfront cottages is from Fox Island, where the Fox Island State Park is now located. The playground is not being used by children staying at the cottages, but there are a few people along the shore and in the rowboats.

71

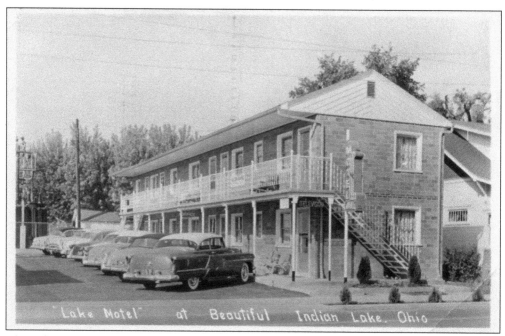

The Lake Motel was located at the southwest corner of Orchard Island Road and East Main Street. In 1921, Pat Sweeney built a hotel there—the Acme Hotel. Later, it was called the Ellmor and the Parker House. Around 1950, Joe Carter purchased the building and converted it into the Lake Motel, preferred by many people over the fancier and larger hotels because it was small. The property was razed to make room for a branch office of the Bellefontaine Federal Savings and Loan. The bank was taken over by Sky Bank in the early 2000s, and Sky Bank was subsequently taken over by Huntington National Bank in 2007. Cars in the parking lot are the typical big automobiles of the late 1950s and offer evidence of the prosperous economic times.

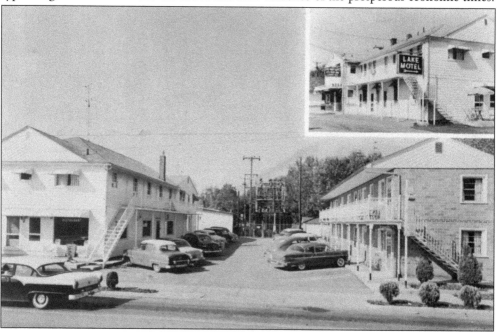

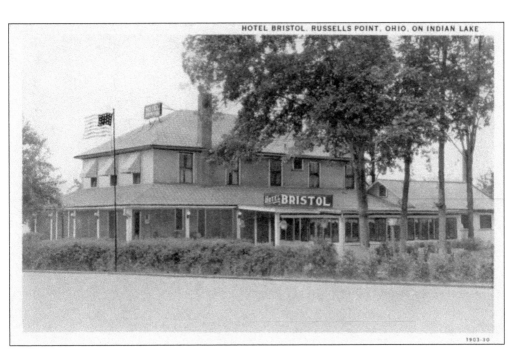

The Smith Hotel was built in 1920 but renamed the Bristol Hotel after its owner, Mr. Bristol. The hotel was located on Bristol Circle across from the harbor in Russells Point. The hotel enjoyed a reputation for hospitality, with comfortable rooms, each equipped with hot and cold running water, which was still a novelty in the 1920s. The below postcard was mailed in 1926, and according to the note on the back, Horace was having a fine time.

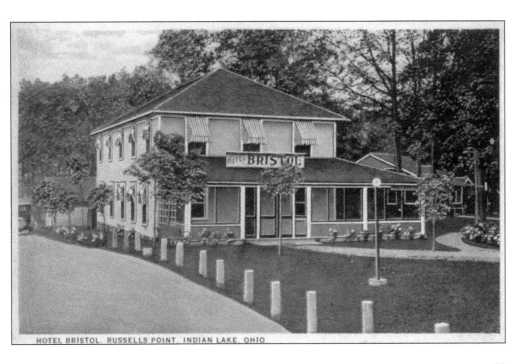

HOTEL BRISTOL, RUSSELLS POINT, INDIAN LAKE, OHIO

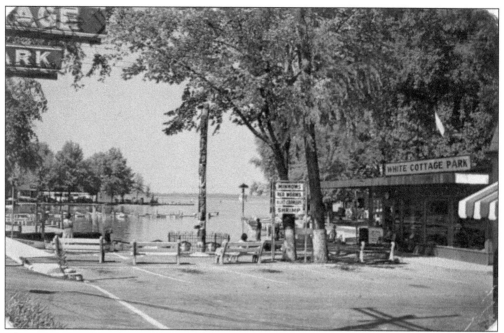

The main office of White Cottage Park was located at the corner of Wilgus Street and Main Street, the current site of Jac & Do's Pizza. The park got its start in the 1900s, when Salathiel Prater owned and operated 20 cottages on Wilgus Drive.

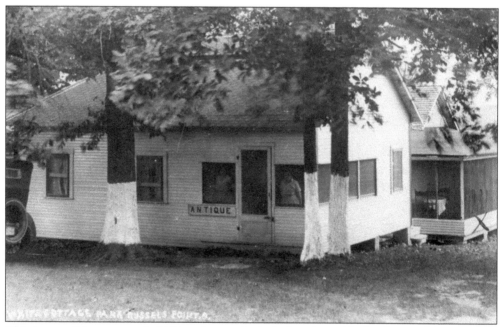

This is one of the cottages in White Cottage Park. In keeping with the theme of the park, the trunks of the trees are painted white. Note the Ford Model T parked on the left and the two women behind the windows on each side of the door. All cottages were named, of course, as indicated by signs on each.

Early cottages often had no foundation and rested on stone blocks. It is not clear whether this was done because all land around the lake was initially leased, to avoid flooding during high water, or because these structures were only considered temporary. This cottage featured a large enclosed front porch over the entire width of the building and upstairs sleeping quarters.

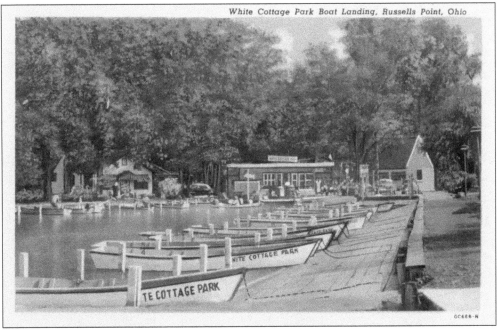

Since the early days of Salathiel Prater, White Cottage Park included a landing with rowboats for rent that guests could use to go out on the water and enjoy fishing or other activities.

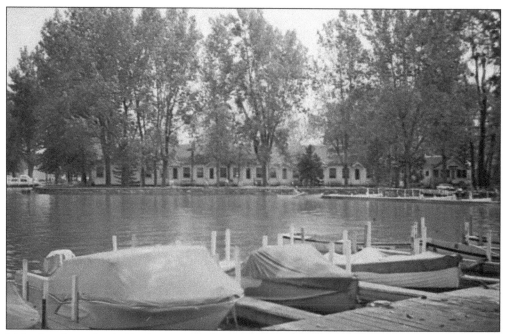

This view from the 1960s shows the White Cottage Landing with cottages and apartments on Point Comfort. The rowboats shown on the postcard on the previous page have been replaced by modest motorboats.

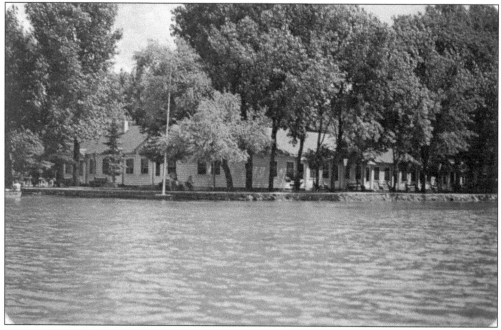

Here is a view from the lake of the apartments at Point Comfort. The apartment building has been replaced by a more modern-looking condominium building.

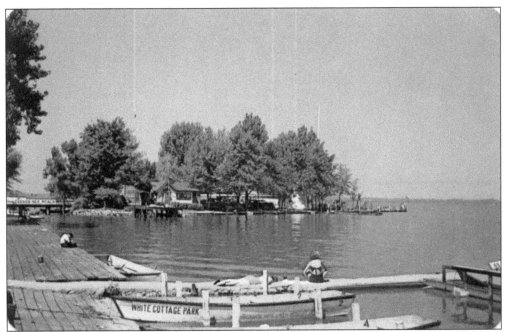

One of the rowboats of White Cottage Park is pictured here with Silver Isle Beach in the background. While it is hard to see, on the side of the bridge to the island is a banner with the name "Silver Isle Beach." The boardwalk was frequently used for fishing, although the man sitting on the boardwalk appears to have fallen asleep. Note the person who appears to be taking a nap on the pier next to the seated woman wearing a bathing suit.

The back of this postcard states that this is a view of White Cottage Landing. However, the concrete entrance to the landing and harbor suggests this may actually be the harbor of Lakeview, located farther to the west.

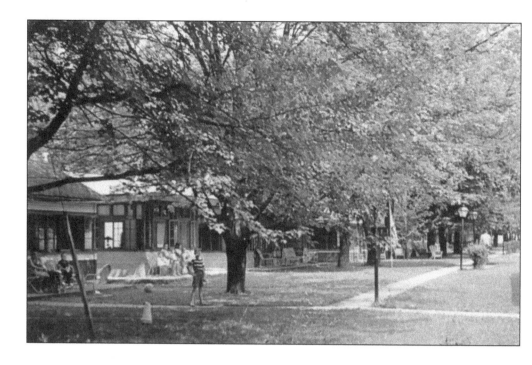

Harden's Beach View Cottages were located at the corner of West Main and North Streets at a "quiet restful location opposite Silver Isle Beach." Sizes of the cottages ranged from one to five bedrooms, with one to ten beds; the promotional text on the back of the postcards promises other amenities to make a stay enjoyable. The cottages were within walking distance of the amusement park.

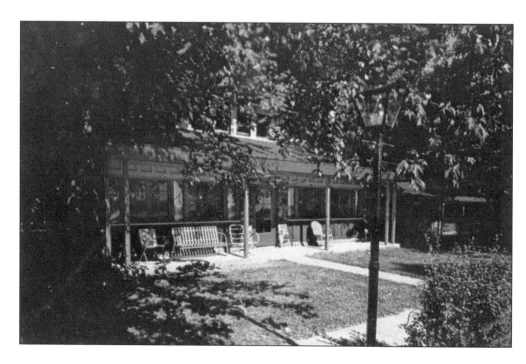

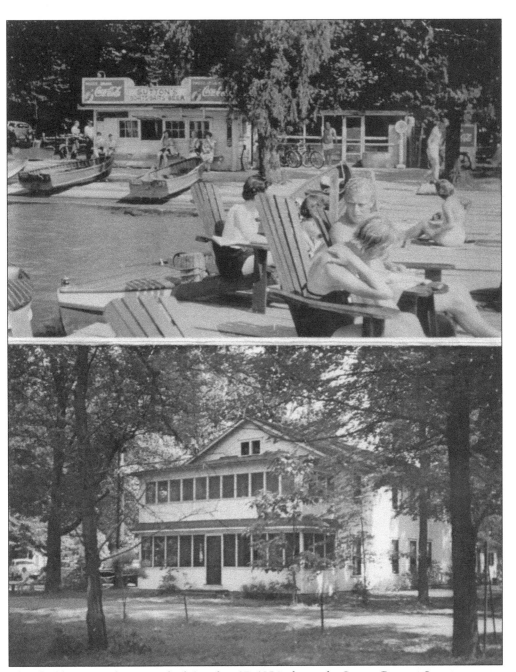

This double postcard, postmarked October 27, 1956, shows the Sutton Resort. Sutton was one of the oldest resorts on the lake and had been catering to vacationers since the 1920s, when is was called the Sutton Brothers Waterbury Hotel and Resort. The resort consisted of 22 waterfront cottages with electric refrigeration and all other modern conveniences of the time. The resort also offered hotel accommodations and a private dock and bathing beach, as well as a convenience store offering beer and lunch. The resort was open from April through November, including the hunting seasons.

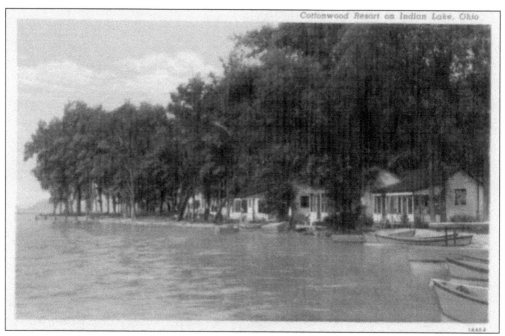

The Cottonwood Resort was located east of the spillway near the location where the Andrus Hotel and landing once stood. As with most other resorts, the cottages are now privately owned. Many of the modest cottages have been replaced by larger vacation homes.

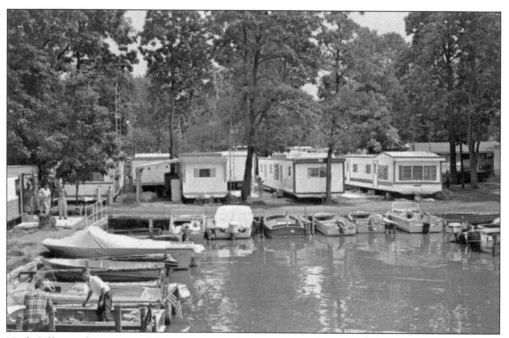

Herb Bill was the owner of the Cottonwood Enterprises, offering modern waterfront trailers, camper sites, a private bathing beach, and mobile homes for rent by the week or for the entire season, with linens included. The mobile homes are still there but are no longer available for short-term rentals.

Hover's Landing was located on the west side of the lake, on the west side of Old Field Island, where the entrance to the Indian Lake State Park is now.

Blackhawk Landing is located on the northwest corner of Indian Lake. The landing is still there, although the small boats shown in this 1960s postcard have been replaced by bigger pontoon boats. Camping in the area is now prohibited, and campers like the one across the channel now have to go to the nearby Indian Lake State Campground.

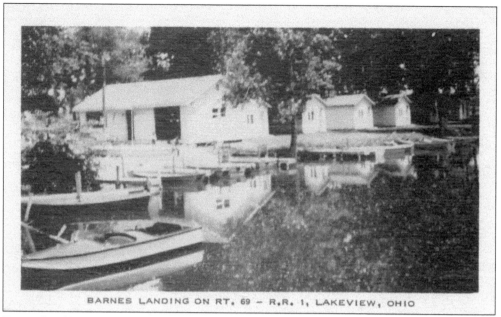

BARNES LANDING ON RT. 69 – R.R. 1, LAKEVIEW, OHIO

Barnes Landing was owned by Nelson Barnes and located on Avondale near the pool that he built in the 1930s.

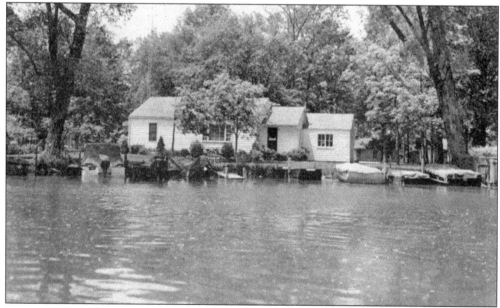

According to an advertisement from 1953, Lou Hull's Turkey Foot Park, on the north side of the lake, not only offered the usual amenities such as boats and cottages for rent, camping supplies, and bait but also offered lakefront lots for sale or lease.

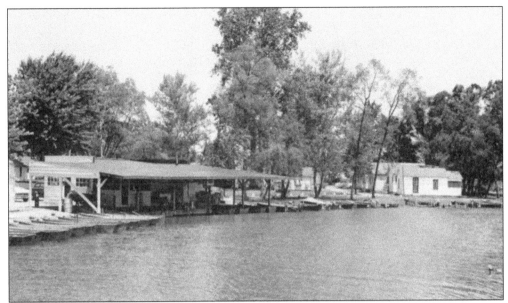

This photograph of Oatman's Resort dates from 1953. The resort offered boats and motors for rent or sale, cottages, a grocery store, and lunch facilities. It was located on Turkey Foot, a peninsula on the north side of Indian Lake. Comparison with the postcard shown below reveals a striking similarity with the Acheson Resort.

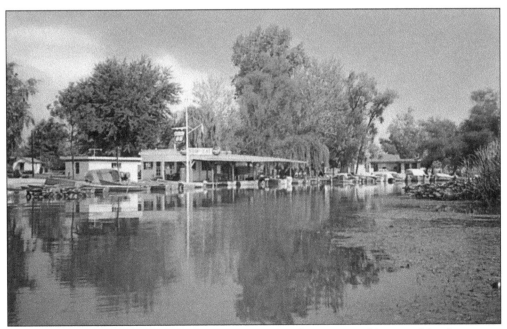

The Acheson Resort opened on April 16, 1955, on Turkey Foot, and is one of the few resorts still open. The resort includes 14 cottages, a restaurant and bar, and several boat docks for patrons of the bar. There is usually live music on Saturday and Sunday. The resort is closed from Labor Day until Memorial Day.

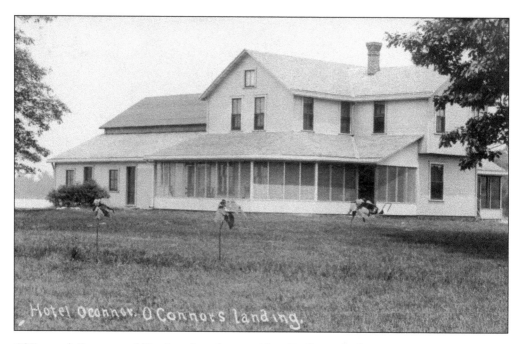

Hotel Oconnor. O'Connors landing.

O'Connor's Resort could be found on the east side of Indian Lake between the North Fork and the South Fork of the Miami River. The O'Connor family bought this land in the 1870s but soon returned it back to the State of Ohio. A few years later, in 1875, James Russell acquired the land for farming and grazing his cattle. In 1895, the estate of James Russell sold the land to Tom and John O'Connor, who were also farmers. In 1904, the brothers built a general store, where they sold bait and tackle among other products. In 1907, they built a hotel of native kiln-dried oak; it had 12 guest rooms, a gift shop, a bait shop, and a restaurant. The above postcard featuring the hotel is postmarked September 4, 1911.

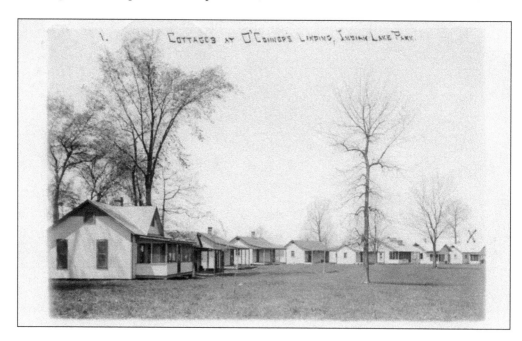

1. Cottages at O'Connors Landing, Indian Lake Park.

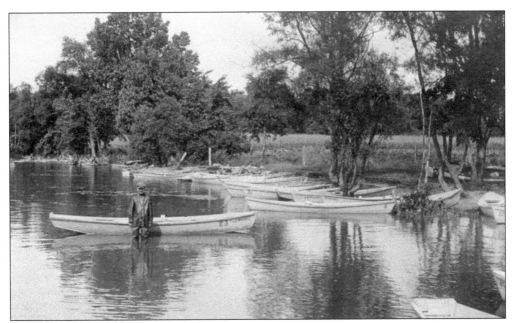

It is unclear why this fully clothed man is standing in the water next to one of the rowboats. Perhaps the boat got loose and drifted away, and a photographer happened to be nearby and immortalized the moment. The lettering is small and difficult to read, but the name on the bow of the boat is "O'Connor."

O'Connor's Resort was a popular place, as shown by the row of cars lined along the road. For the smaller kids, there was a playground. And for the entire family, there was a beach for taking a dip in the water or boats for rent that guests could use to venture out onto the lake.

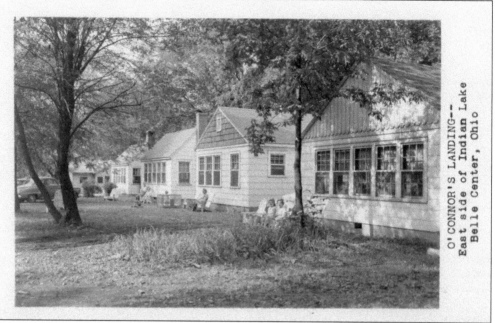

O'Connor's Resort continued to grow to include 30 cottages, a boat landing with docks, and a restaurant in addition to the hotel and general store that started it all. The resort was remodeled several times. This postcard was distributed as an advertisement to vacationers and guests and dates from the late 1950s or early 1960s. Because O'Connor's Resort was located on the east side of Indian Lake, the official postal address was Belle Center, a town some six miles east of the resort.

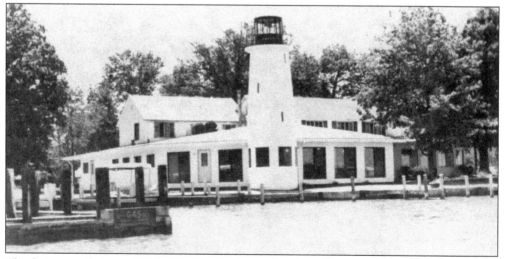

The last time that the hotel was renovated was in the spring of 1985. This last remodel included a major renovation of the restaurant and the inclusion of a lighthouse dining area. The improvements were short-lived, however. In June of that year, an explosion caused a fire that destroyed the restaurant and hotel, and both buildings were unsalvageable and had to be razed. The area is now home to some of the lake's fancier vacation homes.

Five

BEACHES AND SWIMMING POOLS

The earliest visitors to the Lewistown Reservoir were attracted by the fishing and hunting opportunities. As more people traveled to the lake to spend time, a more diverse array of activities developed. The most obvious of these activities was swimming—either at beaches or at swimming pools. Almost every major hotel and resort had its own private beach only accessible to guests. In the heyday of tourism, Orchard Island itself boasted three different beaches, including the first beach on Indian Lake, the State Bathing Beach.

At some of these beaches, patrons swam directly in the lake water. At other pools, the water came from wells, as was the case at Avondale Pool on the north side of the lake. Water that filled the Spa at Sandy Beach came from the lake but only after passing through an elaborate filtering system. Regardless of where the water came from, the lake featured plenty of opportunities for playing, including large water slides and jumping towers, that provided swimmers—including the adults—with enough means to entertain themselves. Around the pool or beach, many spectators would gather to watch those who frolicked in the water.

Nowadays, the only swimming beaches are on Fox Island, next to Orchard Island, and Old Field Beach on the west side of the lake, both operated by the Ohio Department of Natural Resources Division of State Parks.

In the 1990s, the Indian Lake Watershed Project was started to improve the quality of the water in Indian Lake. The watershed project is a nationally recognized project that has made significant water quality improvements during its existence. The quality of the lake water is as good as it was a century ago, and it remains safe for swimming and boating activities.

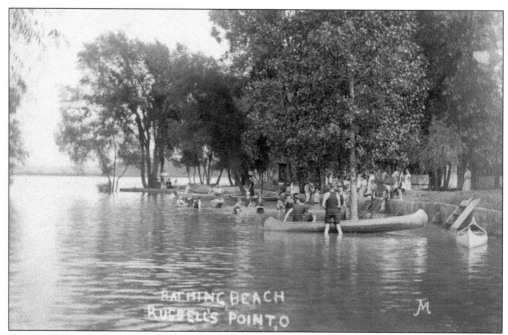

This is an early postcard, dating from around 1910, showing the bathing beach at Russells Point before water slides and other play toys were installed.

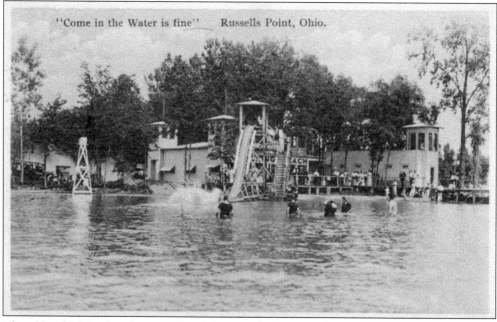

The oldest bathing beach on Indian Lake was the State Bathing Beach located on Orchard Island at the end of Elm Street. This beach opened in 1912 and featured a slide or sliding board that launched swimmers into the water. A lifeguard was on duty whenever the beach was open to the public. It was not unusual to have more spectators watching the swimmers than people actually in the water. This beach is long gone.

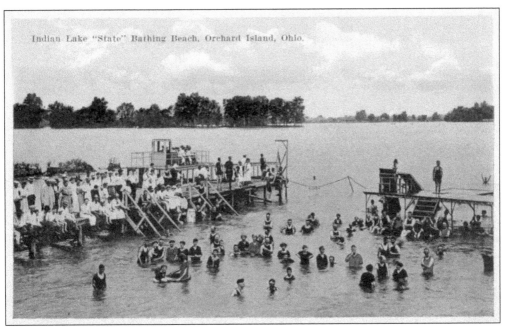

Indian Lake "State" Bathing Beach, Orchard Island, Ohio.

This postcard of the swimming beach on Orchard Island shows the great number of spectators sitting and watching the swimmers. Both men and women wore bathing suits that covered most of their bodies, leaving only the head and (parts of) limbs exposed to the sun.

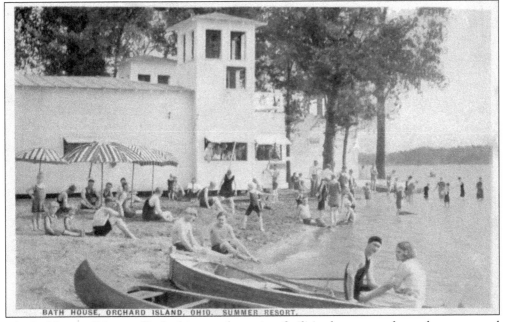

BATH HOUSE, ORCHARD ISLAND, OHIO. SUMMER RESORT.

The bathhouse did not offer bathing or showering facilities but was a place where men and women could change into clothing more suitable for lounging on the beach and going into the water. The sand was brought in from elsewhere to provide a more realistic beach experience.

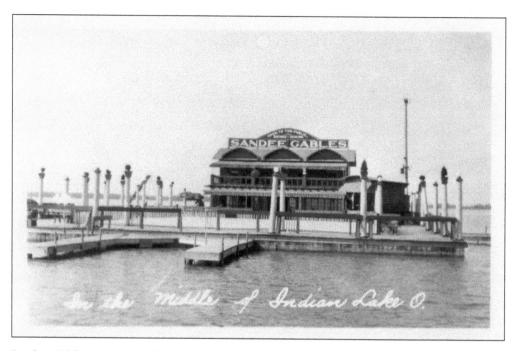

In the middle of Indian Lake O.

Sandee Gables was an artificial island located a few hundred feet west of Wolf Island. The structure was built on a wood and concrete platform and included dressing rooms for the swimmers and rooms for dining and dancing, with bands performing every night. The excursion boat *Evelyn* ferried people to and from the island. The island was initially owned by the Wilgus family but was later sold to Oliver Strauss. The fate of the structure was rather unceremonious: over the years, the lake water caused the wooden supports to weaken and ultimately break, causing the concrete floor to sink to the bottom of the lake, where it probably still rests.

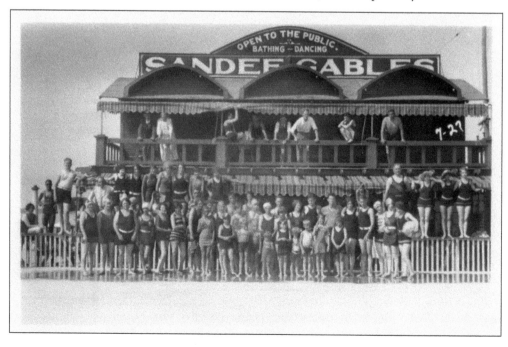

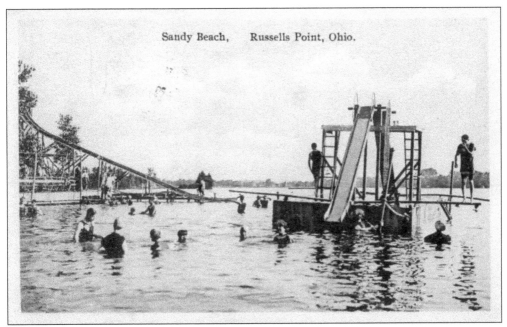

Sandy Beach, Russells Point, Ohio.

Sandy Beach Island opened on Decoration Day, May 30, 1912, and offered good music and dancing in addition to swimming. Regular motorboat service to Russells Point and Lakeview provided access. Samuel Wilgus had leased a small island that was about 50 yards from the mainland in Russells Point, called Duck Island. He renamed the island Sandy Beach and proceeded to install water slides, swings, and diving stands. He also had truckloads of sand brought in to make it a true sandy beach. In June 1918, Matt Edwards, a 31-year-old man from DeGraff, became the first casualty when he suffered a heart attack while riding the roller coaster into the water. He was pronounced dead by the time his body was taken from the water. On Decoration Day, 1924, the Sandy Beach Amusement Park opened, and the beach became connected to the mainland via a footbridge.

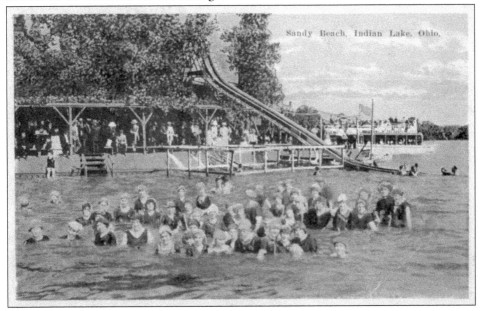

Sandy Beach, Indian Lake, Ohio.

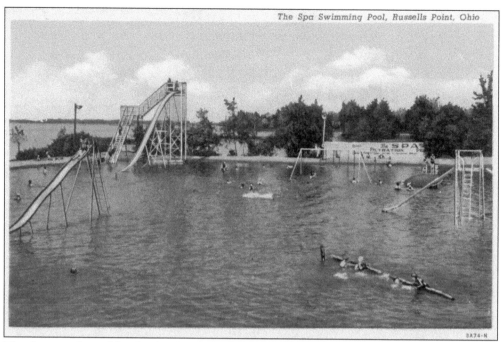

The Spa was formed by dirt banks on three sides and Sandy Beach Island as the fourth side, covered in a layer of sand some five feet thick. The pool was 250 feet long and 800 feet wide, and its depth ranged from a few inches to nine feet. The bathhouse measured 160 feet in length and could accommodate 1,000 visitors. In the early days, the Spa had quite a few toys, including four water slides, four diving boards, a diving tower, and a trapeze. Most of these were gone by the time the picture below was taken. Lifeguards were on duty whenever the pool was open. The pool was filled with water from the lake that had passed through a purification system at a rate of 300,000 gallons per day. For the benefit of patrons wishing to swim at night, 15 powerful lights illuminated the pool.

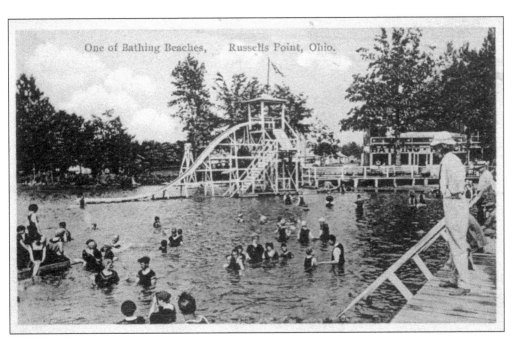

One of Bathing Beaches, Russells Point, Ohio.

Bathing was a popular pastime at Indian Lake not only for children but for adults as well—at times, there were more adults in the water than there were children. Around the lake, there were many opportunities to plunge into the water. All featured water slides and diving boards. Few of these facilities remain, and the only swimming opportunities available today are at the state beaches on Fox Island, just east of the bridge to Orchard Island, and Old Field Beach, on the west side of the lake. Neither has slides or other toys available for the enjoyment of swimmers.

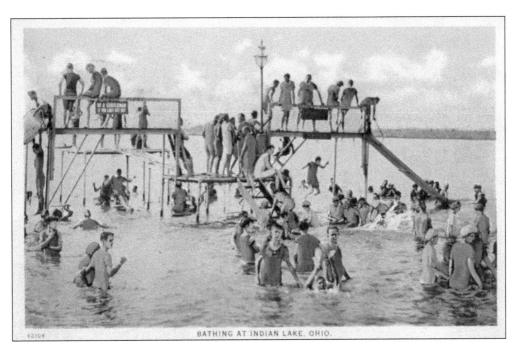

BATHING AT INDIAN LAKE, OHIO.

The larger hotels and resorts had private beaches for their guests. The sandy beach shown in this postcard belonged to the Wicker Hotel and Resort and was located at the north end of Orchard Island.

The Sun-n-Sand Beach belonged to the Beatley Hotel and featured a sand beach as well. It was located across the street from the hotel on Holiday Beach Lane.

Bathing Scene, Silver Isle, Russells Point, Ohio 4B397-N

Silver Isle Beach was located on a small island west of White Cottage Landing opposite of North Street. The beach had no sand, but the grassy area offered ample opportunity for sunbathing and watching other people. The beach also offered the usual slides and rides. It remained a popular place into the 1970s. The island, which was some 25 yards from the mainland, was accessible via a footbridge.

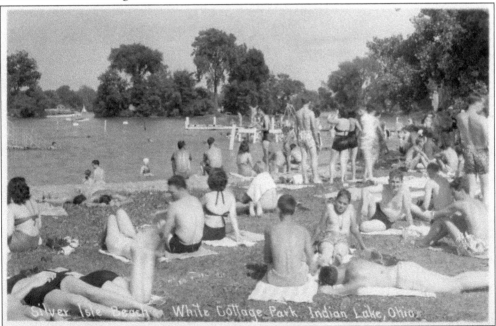

This postcard dating from the early 1960s shows the evolution of bathing suits from the full-body cover worn at the beginning of the century (and shown earlier in this chapter) to a style that exposed a lot more of the body to the sun—and perhaps also to other swimmers and onlookers. Most of the visitors still appear to be young adults.

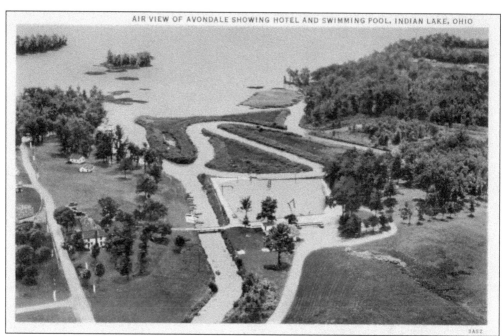

This south-looking aerial view of Avondale, located on the north side of Indian Lake, shows the sparse buildings as compared to how it looks today. The hotel in the center left is now gone, and the entire area east of the channel is now built up with waterfront cottages. The bridge connecting the hotel with the pool is gone, as is the pool itself. The only reminder that a pool ever existed is the name of the road in the bottom center, Avondale Pool Road. The pool area is now the home of the Smuggler's Cove, with 167 RV lots in what is claimed to be "Indian Lake's premier RV family campground." Smuggler's Cove does have a small swimming pond. The Chippewa neighborhood now occupies the upper right corner of the postcard view. The small islands south of the pool remain uninhabited.

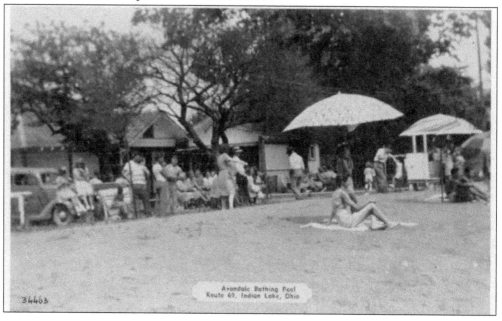

Avondale Bathing Pool
Route 67, Indian Lake, Ohio

96

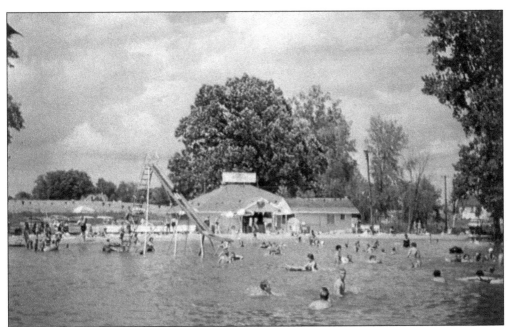

Avondale Beach and picnic area was built in the mid-1930s by Nelson Barnes, who had the entire beach first excavated and then filled with sand brought in on 100 railroad cars. The pool featured water slides and, at some point, a very tall diving tower. This was the only pool on the lake that was filled with well water. There was a shallow part especially for smaller children.

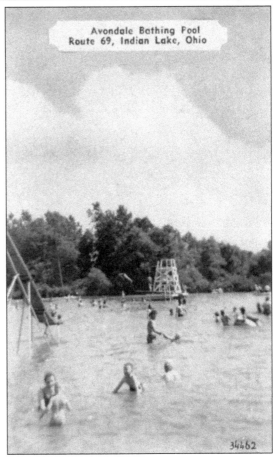

Avondale Bathing Pool
Route 69, Indian Lake, Ohio

34462

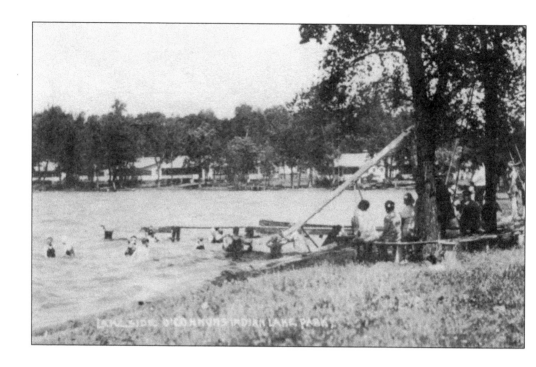

On the east side of the lake, O'Connor's Resort remained a popular vacation place into the 1980s. It featured a swimming area that included a slide into the water and a pier for diving. When he was not working at the general store, Pat O'Connor, the eldest son of Tom, used to give unplanned swimming lessons to the younger children.

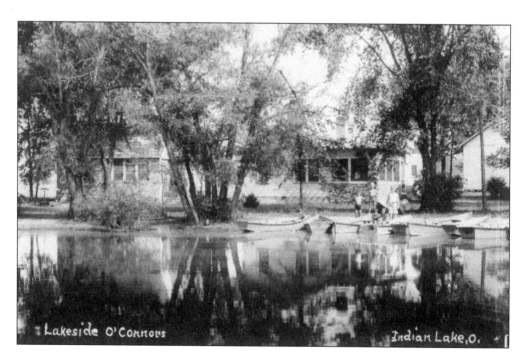

Six

AROUND INDIAN LAKE

Indian Lake has a total shoreline of around 30 miles, with many coves, peninsulas, and islands connected by bridges to the mainland. Driving around the lake takes several hours, especially if one also wants to explore places such as Sassafras Point, Turkey Foot, Long Island, and the Indian Isles in the middle of the lake (accessible by Ohio Route 368). Travel these days is a breeze compared to a century ago, when travelers were faced with unpaved roads that became almost impassable after a heavy downpour.

As G.H. Palmer wrote on March 21, 1921, in the *Bellefontaine Examiner,*

> The highway from Bellefontaine to where we turned off the Huntsville Belle Center Road was generally in good condition but from that point on—well, there would be stretches of clay, stick mud which would roll up on the wheels till from its own weight it would fall off with a thud, or if too tenacious was pushed off with a stick. There were other stretches of soupy mud in which the horses' hoofs came down plunk, plunk with little waves spreading out from the wheels as they revolved. Sometimes an unsuspected mud hole let a wheel down quite to the axle which necessitated our climbing out and with a pole of fence rail, prying up the offending member for a new start.

The first successful use of Portland cement concrete as pavement was in 1893 for the road around the courthouse in Bellefontaine, some 10 miles east of Indian Lake. After this, the use of cement in road construction took a giant leap forward. In 1921, the first cement road came to Indian Lake. This last chapter provides miscellaneous views from around the lake, starting at the waste weir and traveling clockwise around the lake.

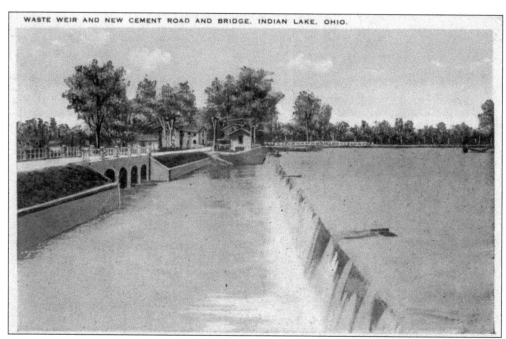

WASTE WEIR AND NEW CEMENT ROAD AND BRIDGE, INDIAN LAKE, OHIO.

The first concrete or cement road in the Indian Lake area was US Route 33—now State Route 366. The first stretch was built in 1921 from the Auglaize County line to Lakeview. A second section ran from the waste weir to Lakeview. The bridge and embankments received a face-lift, and their appearance was much neater than what is shown on older postcards. In the early 1920s, a new cement road was big news for the community. In June 1926, the *Lima News* raved about the "excellent concrete road extending from Lakeview to Russells Point and for hundreds of miles in both directions from those towns. A series of lights are being installed high above the heads of the occupants of speeding automobiles." The age of the automobile had arrived!

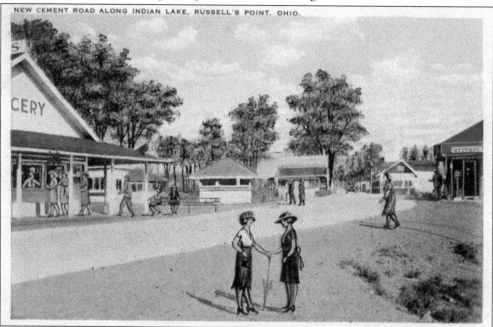

NEW CEMENT ROAD ALONG INDIAN LAKE, RUSSELL'S POINT, OHIO.

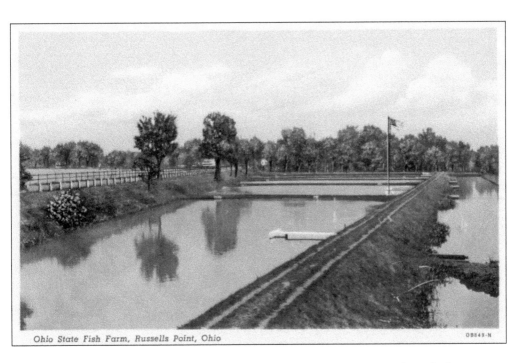

Ohio State Fish Farm, Russells Point, Ohio

OB849-N

According to earlier accounts, there were two fish hatcheries at Indian Lake. The largest one, shown here, was a short distance from the spillway, south of the road. The hatcheries, which were in operation from the 1930s to the 1950s, ensured the lake was always stocked with fish. The second, smaller hatchery was believed to be located at the north end of Artist Isle. However, this aerial view looking eastward at Artist Isle shows only a pier extending north into the lake, with the fish hatchery located south of the waste weir shown in the background.

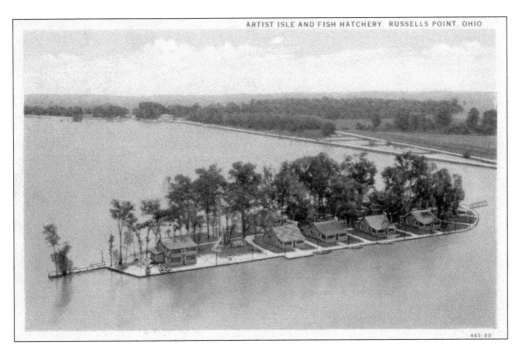

ARTIST ISLE AND FISH HATCHERY. RUSSELLS POINT, OHIO

465-30

101

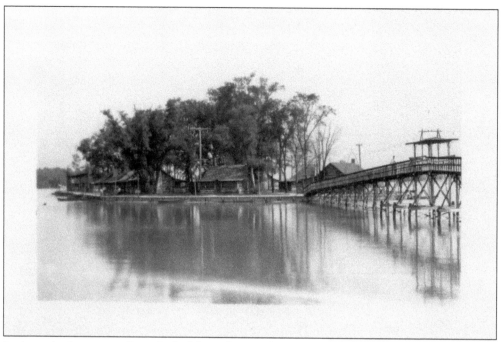

In the early days, access from Artist Isle to the mainland was via a footbridge. Roscoe Ails built cottages on the island to provide a secluded place for his fellow actors to get away from life in the big city. The island also served as a retreat where actors could prepare for upcoming shows. He had a stage erected from which he and his fellow actors would entertain guests.

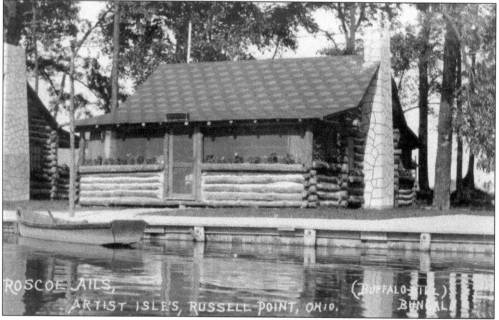

Roscoe Ails was a vaudeville actor who mostly worked in the early 1930s with his wife, Shirley Dahl, appearing in films such as *See, See, Senorita* (1935), *The Policy Girl* (1934), and *Darling Enemy* (1934). In 1929, Ails had several cottages built on the island and instructed the builders to keep a rustic appearance, which explains the log cabins on the island.

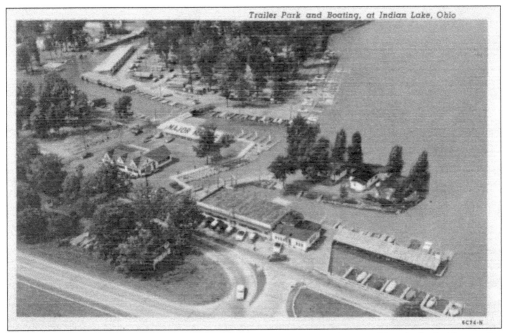

The trailer park is on an island created by digging a channel and accessible via the bridge to the left of the Major Marine storage building in this aerial view. The building with the flat roof in the foreground is the Wedge Resort. Old US Route 33, now State Route 366, runs directly along the lakeshore; the new highway is visible in the lower left corner.

MAJOR MARINE, RUSSELLS POINT, OHIO

Major Marine, established around 1930, offered complete marine services, including boats for sale or rent; a full line of marine hardware, paints, and supplies; and dock and storage space. The gasoline pump in front of the building provided gas for highway travelers; a second gas pump was located at the docks for serving boaters.

103

St. Marys of the Woods Catholic Church, Russells Point, Ohio

In 1921, the Catholic clergy in Bellefontaine started holding Sunday services in the coliseum on Orchard Island. By 1927, the original church building was constructed; Sunday Mass was celebrated during the summer months only. As the Catholic population grew, year-round services became a necessity. In August 1956, the tabernacle, with its sacred contents, was stolen from the church's sanctuary; it was never recovered. On February 11, 1961, just after renovations of the sanctuary had been completed, the entire interior of the church was gutted as a result of arson. Religious services were continued at the dance hall of the amusement park. On July 29, 1962, the new and expanded church building was dedicated.

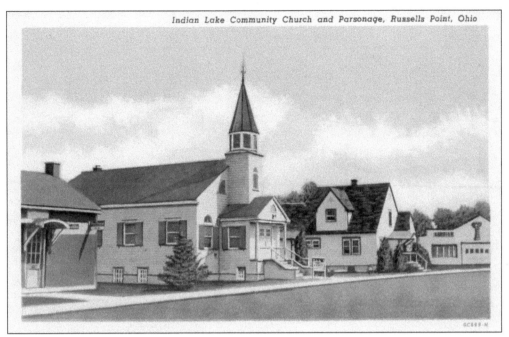

This late-1940s view of the Indian Lake Community Church shows the post office to the left and the parsonage to the right of the church. The church is located along the road leading to Orchard Island and started in 1923 as the Union Sunday School. The present church was built in the 1930s and has been remodeled at different times and now features two bell towers. The parsonage was built in 1944 and moved elsewhere in 1987. The post office has been replaced by a metal building.

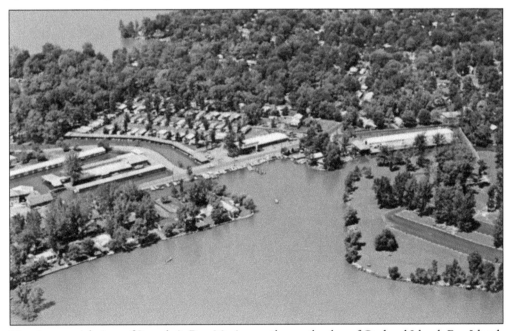

Here is an aerial view of Spend-A-Day Marina on the south edge of Orchard Island. Fox Island, with one of the state parks and swimming beaches, is in the lower right.

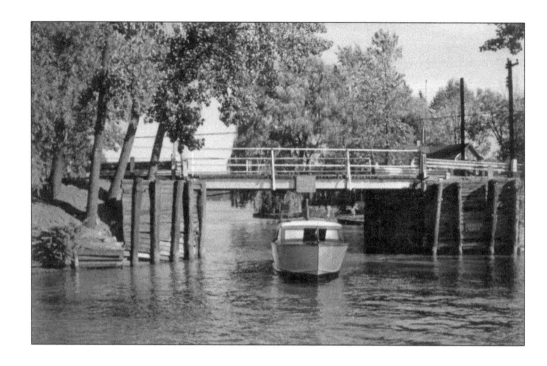

The first bridge to Orchard Island was built in 1901 by Frank "Shad" Reed to provide easy access to the Orchard Island Hotel. Since then, the bridge has been rebuilt and enlarged several times.

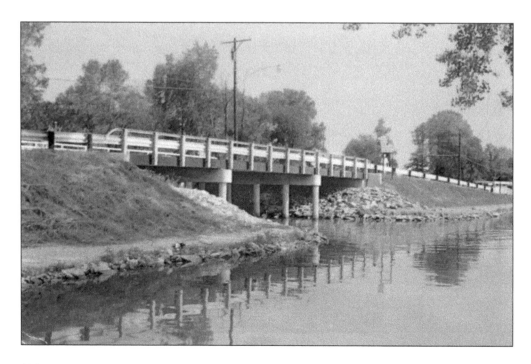

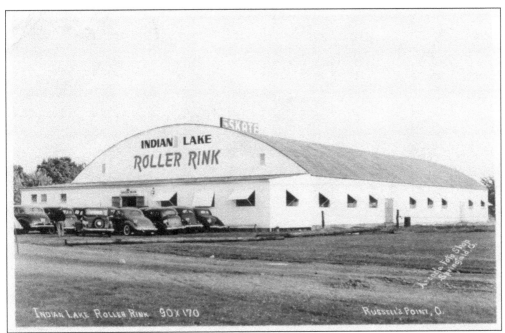

The Indian Lake Roller Rink on Taylor Street in Russells Point was built in 1939 by Harry Lawrence and Madge Volz and is one of the few attractions that remains in business. It is currently known as the Indian Lake Rollarena and offers spacious accommodations for a serious workout or for a more relaxed outing. Kids are welcome to join in the fun at this club where adults can feel like kids again!

In the early years, there was considerable interest in sailing and in the Indian Lake Yacht Club (ILYC), but it seems that the club slowly died out in the late 1930s. According to its website, the current ILYC claims that it was founded in 1945 as a family-oriented sailing and social club. In 1948, a clubhouse was built on an island now fully connected to the mainland, with boat docks and a picnic shelter on an adjacent island connected by a footbridge.

This is the front of an advertising postcard for the Harbourside Condominiums that were built in the late 1980s on the former site of the Sandy Beach Amusement Park.

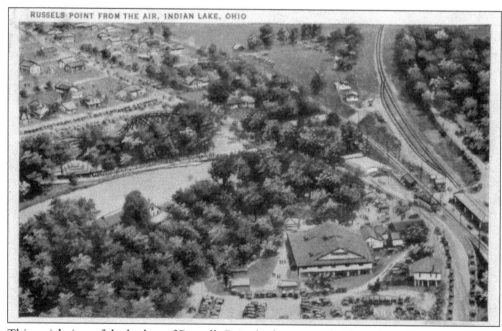

This aerial view of the harbor of Russells Point looks eastward. The railroad station and tracks are visible on the right.

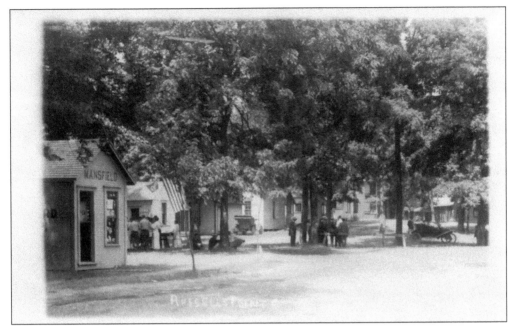

Postmarked 1913, this postcard shows the studio of Harry Mansfield, one of the photographers who captured many scenes around Indian Lake in the first decades of the 20th century. To the right of the studio, people are congregating outside of a building from which an American flag is flying. The smaller flag on the same pole appears to be from the Indian Lake Yacht Club. Perhaps this photograph shows a Fourth of July celebration.

Captain Gillwater is shown smoking his pipe as he sits and relaxes on the bow of one of the tourist boats waiting for guests to take a cruise around the lake.

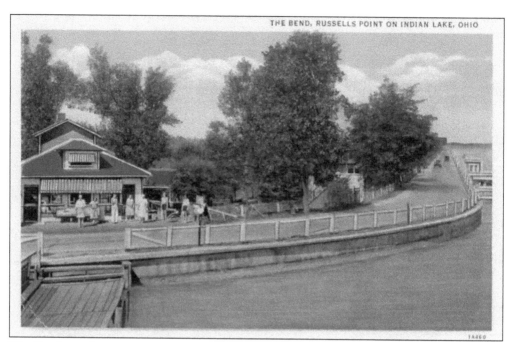

The Bend was the name given to a sharp turn in the road along the south shore of the lake just west of Russells Point. On August 1, 1937, the Bend became the scene of one of the most tragic automobile accidents to ever occur in the Indian Lake area. Six people had visited Russells Point and were on their way back to Lima when, at around 1:00 a.m., the car in which they were traveling failed to negotiate the sharp turn in the road. Only one of the six people in the car was rescued, by passing motorists who dove into the water and pulled the survivor to safety. The other five could not be reached in time as the car sank into the lake. The below postcard shows the view looking east.

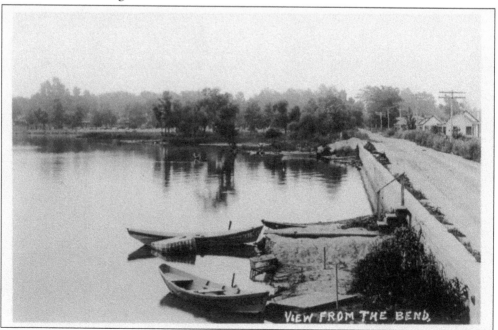

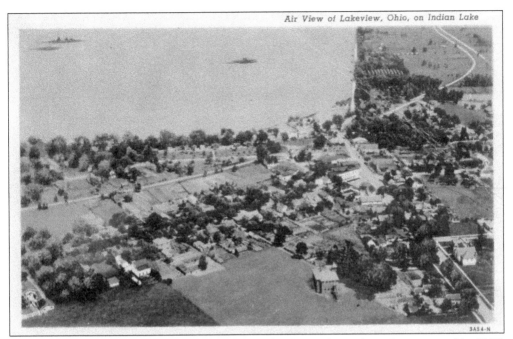

Lakeview is located at the southwestern corner of Indian Lake and was incorporated in 1885. This card is postmarked July 20, 1944. The three small islands visible in the upper left of the postcard have since disappeared as a result of erosion.

This card featuring a bird's-eye view of Lakeview was posted on July 17, 1911. On many of the earlier postcards, the name of the village is written as "Lake View." The road appears to be Lake Street. Note the laundry line visible at lower left.

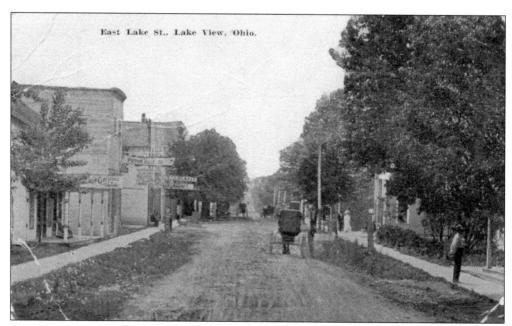

The first mayor of Lakeview was Elisha Houchins, who served in 1895 and 1896 and passed an ordinance to build sidewalks in the village. This postcard shows that the condition of the sidewalks was a lot better than that of the dirt road, even on one of the major roads through town.

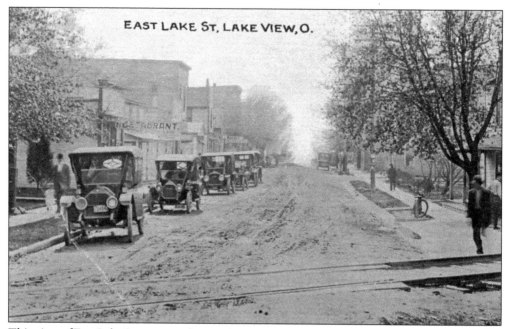

This view of East Lake Street was taken at a later date. The horses and buggies have been replaced by automobiles. The tracks of the electric interurban train are visible in the foreground.

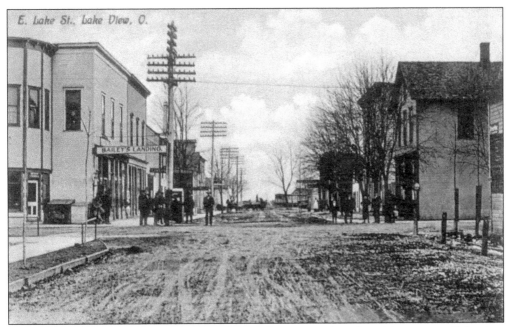

This view of Lake Street must have been taken after 1912, when electricity came to Lakeview and distribution lines were installed thanks to a bond issue of $1,200. Bailey's Landing, owned by Emmett Bailey, was located at the corner of Lake and Main Streets.

Digging up the streets in Lakeview got them ready for paving with concrete, which made travel a lot easier for automobiles.

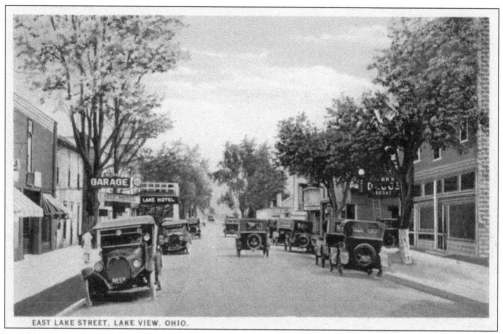

EAST LAKE STREET, LAKE VIEW, OHIO.

In 1920, Lakeview had concrete streets built, which made traveling through town much easier. The garage shown on the left was a full-service station that opened in 1913.

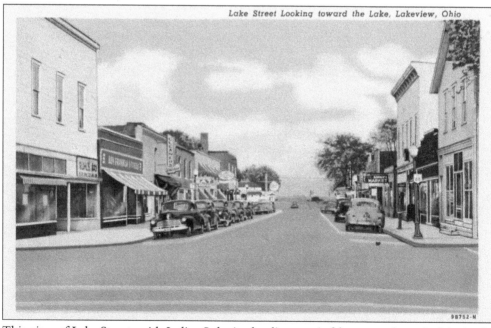

Lake Street Looking toward the Lake, Lakeview, Ohio

This view of Lake Street, with Indian Lake in the distance, is fake—or at least the lake in the distance is. The lake cannot be seen from this vantage point at the intersection with Main Street. What used to be Bailey's Landing is the white building on the left. The brick buildings at the end of the street are now gone.

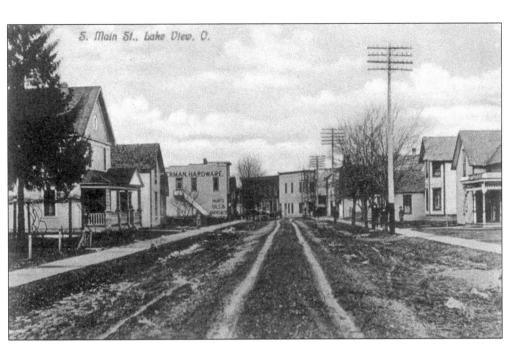

These postcards offer 1920s views of a muddy Main Street in Lakeview.

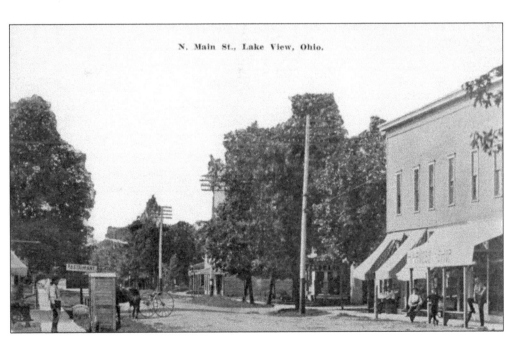

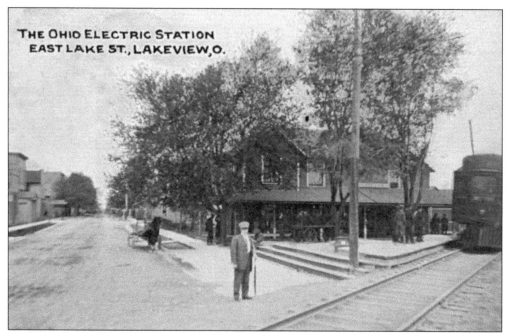

This postcard shows the railroad depot along with an interurban railcar. The interurban was an electric railway with streetcar-like light electric self-propelled railcars that ran within cities and between nearby cities or towns. They were very prevalent in North America between 1900 and 1925 and were primarily used for passenger travel between cities and their surrounding communities. The Ohio Electric Railway came to Lakeview in 1908, bringing more vacationers to Indian Lake.

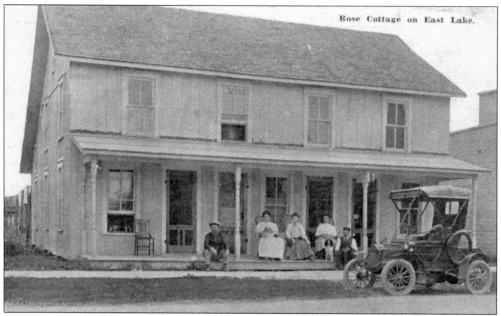

Rose Cottage may have been an early form of boardinghouse or apartment building, with several front doors indicating the different living spaces.

In 1931, the first seaplane to land on Indian Lake was piloted by Jim Krouskop. The pilot shown in this postcard is unidentified. Excursion flights were popular in those days, with several pilots offering sightseeing trips. There were several small airfields around the lake, and airshows were regularly held and featured famous stunt fliers.

Nickell Flying Services was owned by Roger and Bernita Nickell. The airfield was two miles north of the lake near Turkey Foot. It offered a variety of services, including charter services; flight instruction; aerial application seeding, fertilizing, and spraying; and airplane tours and rides.

HERMIT ISLAND, MYER'S, AND POTTER.

Hermit Island—now also called Ewing Island—was named after George Katzel, who settled on the island and lived much like a hermit after his wife died in 1882. Katzel formerly resided in Marion and served with distinction during the Civil War. He preferred his solitary lot and lonely abode on the island in one of the most desolate spots, despite offers from his children to come live with them. Katzel's main occupations and means of living were fishing and beekeeping. Katzel, who was 67 years old in 1905, wore a long grey beard reaching down close to his waist; the beard was kept inside his coat so that visitors saw what appeared to be a short-cropped beard. The postcards suggest the island was also popular for fishing and included a boat landing. A few buildings remain on the island, but otherwise, it still is a place of solitude—if not desolation.

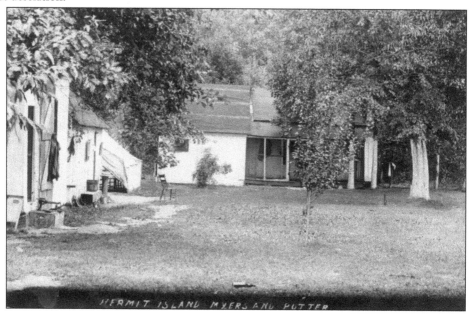

HERMIT ISLAND MYERS AND POTTER

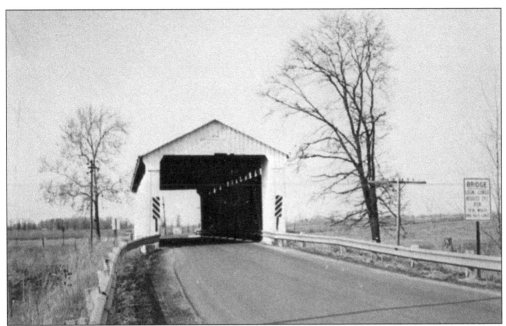

John Bickham was a farmer with several acres of land on both sides of the South Fork of the Miami River. To get across the river, he had a solid covered bridge built by the Smith Bridge Company. The 102-foot-long bridge was built in 1877 using white pine boards that were too pretty to paint, according to Bickham. In later years, the bridge was the only way to reach O'Connor's Landing; the postcard shown below is postmarked July 12, 1938. At some point, Bickham Bridge was painted white. In 2001, the bridge was repaired and painted red. This is one of only two covered bridges remaining in the area. The McColly Bridge, built in 1876, is over the Great Miami River in Washington Township. The covered bridge at the spillway was washed away during a flood in the first half of the 20th century.

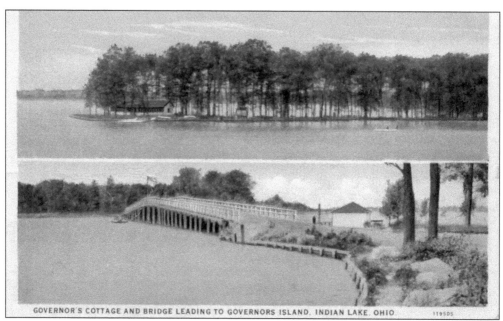

GOVERNOR'S COTTAGE AND BRIDGE LEADING TO GOVERNORS ISLAND, INDIAN LAKE, OHIO.

Governor's Island is just southeast of Shawnee Island; both islands are connected by a narrow strip of land. The island is named after A. Victor Donahey, who acquired the island while he was serving as governor of Ohio (from 1923 until 1929). In 1934, Donahey won election to the US Senate, and he served one term from 1935 to 1941. The island is now home to the Marianist Family Vacation Retreat, which offers a five-day retreat to better bond families rooted in Catholic Marianist values.

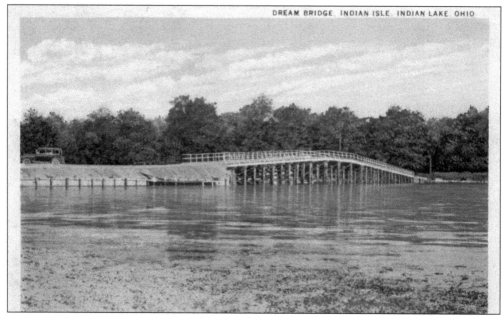

DREAM BRIDGE, INDIAN ISLE, INDIAN LAKE, OHIO

Dream Bridge connects the Indian Isles with Lake Ridge Island. The first bridge was built in 1935, and measured 26 feet wide and 150 feet long. In 1990, the bridge was replaced with a new one of similar design to the old bridge that measures 40 feet wide. During construction, one-lane traffic was maintained.

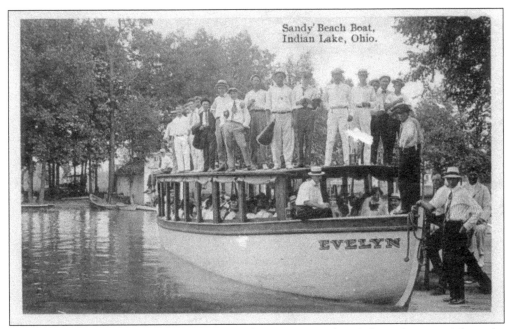

The *Evelyn* was the largest sightseeing boat of its type on Indian Lake and operated from the late 1920s until 1956. It was owned by Henry Blum and Cliff Binkley and named after French Wilgus's daughter. A tour on the boat cost 25¢. The boat had two decks, with the top deck partially open and partially covered by a canopy. Small orchestras came on board to entertain guests during moonlight cruises. This postcard of the *Evelyn* at the public landing in Russells Point is postmarked August 15, 1917.

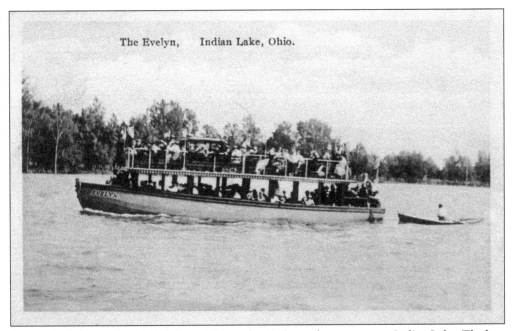

Postmarked August 18, 1919, this card shows the *Evelyn* on her way across Indian Lake. The boy or man in the rowboat does not seem to have a problem keeping up with the *Evelyn*.

This 1953 photograph shows the men who patrolled Indian Lake for 20 hours every day, making sure boating and fishing remained safe for all. Shown from left to right are Maurice Place, Charles Laycock, L.R. Cooper, Jerry Philips, George Weaver, Emery Walters, and Chief L.R. Colvin.

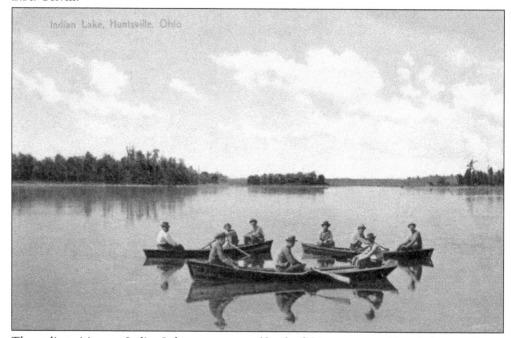

The earliest visitors to Indian Lake were attracted by the fishing opportunities. At first, rowboats were used to get to fertile fishing grounds, followed by boats with a small outboard motor.

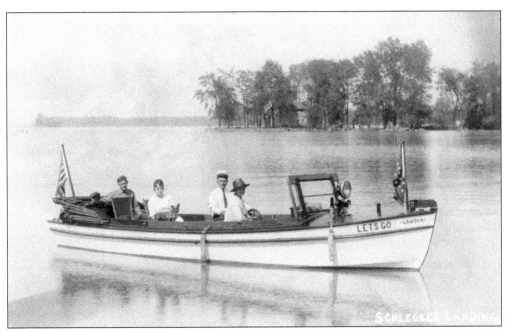

Captain Lawson, shown in this postcard wearing a tie and cap, is piloting the boat *Let's Go* from Schlegel's Landing. This real-photo postcard shows an excellent view and example of the wooden motorboats popular in the 1930s and 1940s. Lawson also piloted other boats at the lake. Bellefontaine Island is in the background.

B 1472 Row Boating From Sheltered Coves on Indian Lake, Ohio

Children enjoy a bit of physical exercise as they row their boat near one of the many sheltered coves around Indian Lake.

This typical view of Russells Point in the early days shows a rowboat and simple cottages, with trees still growing in the water.

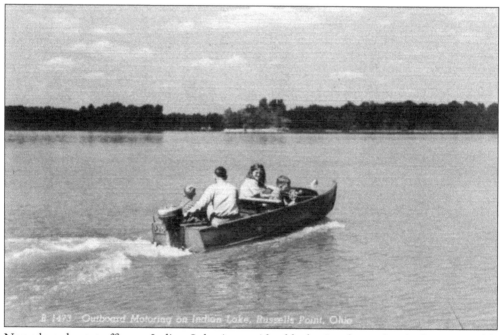

Nowadays, boat traffic on Indian Lake is considerably busier than what is shown on this postcard. Pontoon boats are now the norm instead of the smaller boats of yesteryear. One of the major marinas around the lake, Bud's Marine, is also known as Pontoonland and offers the largest selection of pontoon boats in Ohio.

This early bridge connected Ridge Island to the mainland. The swampy areas spanned by the bridge were a haven for mosquitoes. While most of the swamps are gone, mosquitoes are still a nuisance on the Indian Isles, and during the summer months, fogging takes place every Wednesday.

Pictured here is a winter scene on Paradise Island. The trees and shrubs are covered with ice, a view that can still be seen when strong winds force the lake water onto the shores.

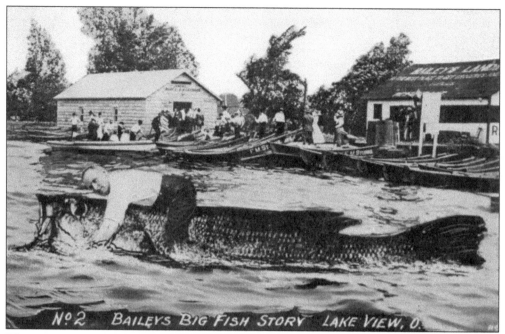

There are many postcards showing the big fish living in the lake attacking boats and fishermen. Most of these cards are generic and sold at every lake resort. Very few postcards show the big fish that actually live in Indian Lake. Some of these fish in the lake were big enough to use as floatation devices, as shown by Emmett Bailey at Stubb's Landing in Lakeview.

This little pony drawing a cart made out of a barrel was a popular feature around the lake. Sometimes, the cart was drawn by a goat about as tall as the pony. The photographs taken with people in and around the cart provided a fun souvenir for those who visited.

Peaceful scenes on Indian Lake, where one can observe nature in solitude, have attracted people since the beginning of the 20th century, which is when these photographs were taken.

Visit us at
arcadiapublishing.com

Printed in the USA
CPSIA information can be obtained
at www.ICGtesting.com
LVHW060755201123
764349LV00045B/1513

9 781467 102520